The Best Places to PEE

A GUIDE TO THE FUNKY & FABULOUS BATHROOMS OF PORTLAND

SECOND EDITION

KELLY MELILLO

Second Edition
ISBN 978-0-9851893-2-7
Copyright 2013

Silent 7 Publishing

The Best Places To Pee: A Guide To The Funky & Fabulous Bathrooms of Portland
www.thebestplacestopee.com
All Rights Reserved

Printed in The United States of America

Cover Photo: Vivian Johnson
Cover Design: Stefanie Fontecha www.beetiful.com

Great effort was taken to ensure all the information in this book is 100% accurate and up-to-date as of the press date; however, things can and do change rapidly in the restaurant industry. So before you set up a "loo tour," it never hurts to double check the facts before you "gotta go."

Special Sales
The Best Places To Pee: A Guide To The Funky & Fabulous Bathrooms of Portland is available at special discounts on bulk purchases for corporate, club or organization sales promotions, premiums, and gifts.

For more information, contact Silent 7 Publishing
girlonthegopdx@gmail.com

The Loo Crew
Author..Kelly Melillo
Photography..Kelly Melillo and Jeff Freeman
Editors...Rachel Guerin and Ali McCart
Book Designers..Craig Williams and Vinnie Kinsella

To Tommy, Michael and Maxwell whose authentic, beautiful, selves bring love, learning and laughter into my life on a daily basis. Thank you for embracing my quirky sense of humor, nurturing my sentimental side, and managing all the AV equipment in our house. I adore you boys.

Contents

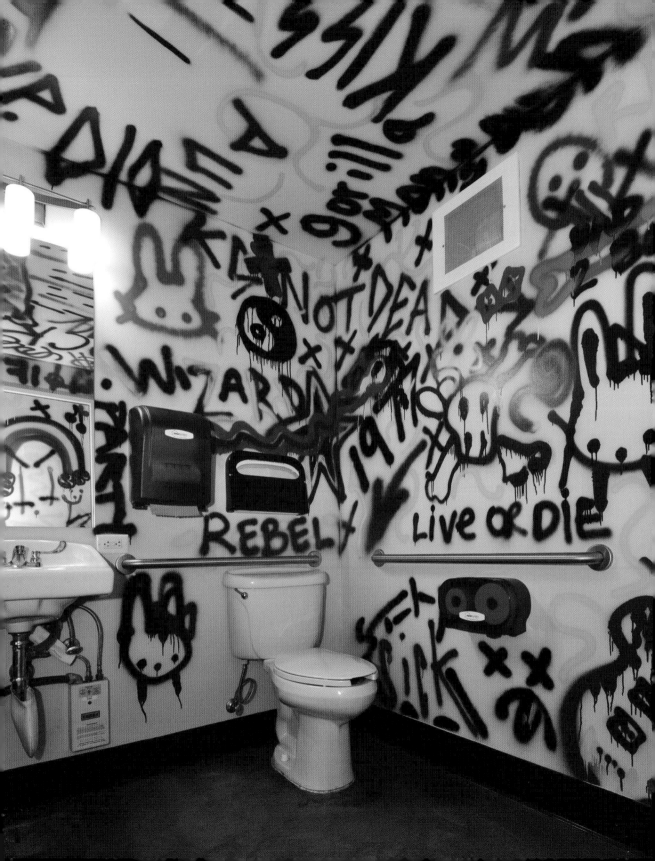

Introduction

BEING A WATER CLOSET CONNOISSEUR WAS NEVER AN ASPIRATION OF MINE. I HAD ASPIRATIONS OF LIVING IN THE ST. Gregory Hotel and learning about the fascinating lives of its guests, just like Christine from the '80s TV series *Hotel*. And being romantically involved with the handsome and very charming James Brolin seemed like a perfectly lovely way to live out my adult life. But sometimes life has a different plan for you, and when these treasures bestow themselves on you, it's up to you to recognize their significance.

Over the past few years, I've found myself intrigued by the stories of a vastly different kind of venue—bathrooms!

This quirky fascination grabbed me, held my attention, and drove me forward with a desire to explore Portland's porcelain—and three years later, I turned it into my first book. To my wild surprise, it turns out that *people love to talk about a good bathroom!* People remember a good bathroom for a long time. They Instagram it, Facebook it, tweet it, pin it and tell people about it the next day.

I began to see the value in this topic. Beyond exploring an evergrowing collection of unique bathrooms, I found equal joy in learning the history of these businesses, the buildings and the people who are running them. I began to realize I was sitting between the seen and unseen details of each establishment, and learning the stories that connected the two.

These stories and facts are as unique to the owners as they are representative of the neighborhoods in which the businesses reside. They create insight into the many distinct neighborhoods of Portland.

It is proven that stories are powerful drivers of emotional value and have a profound effect on how people look at and relate to any given object or place. Stories are shared and people relate to them, smile about them, feel excited about retelling them. *The Best Places to Pee* combines my passion for uncovering the rich stories embedded within local establishments and the gift of connecting people with them in a fun and engaging way.

My wish is that locals, visitors and bathroom buffs alike will treat this book as an imaginative roadmap that uses funky and fabulous bathrooms as a navigational tool for exploring the city beyond the highlights of a traditional guidebook. Its pages lead you on a journey through Portland's hip and trending present while sharing parts of its past and allowing you to become acquainted with the people behind these businesses. Informative and witty summaries provide you with stories that will broaden your explorations and shape your memories.

So although I live in a house instead of a hotel and rather than James Brolin I have the company of three handsome men, to me, my life does indeed resemble the TV series *Hotel*. My days are formed by a revolving door of rich stories about people, places and spaces. It's awesome!

The Best Places to Pee: A Guide to the Funky & Fabulous Bathrooms of Portland offers an offbeat and distinctive sketch of Portland that lovingly mirrors the city's renowned reputation as one of the hippest and most popular places to visit and live. It's a fun and fresh way of exploring Portland.

—Kelly Melillo

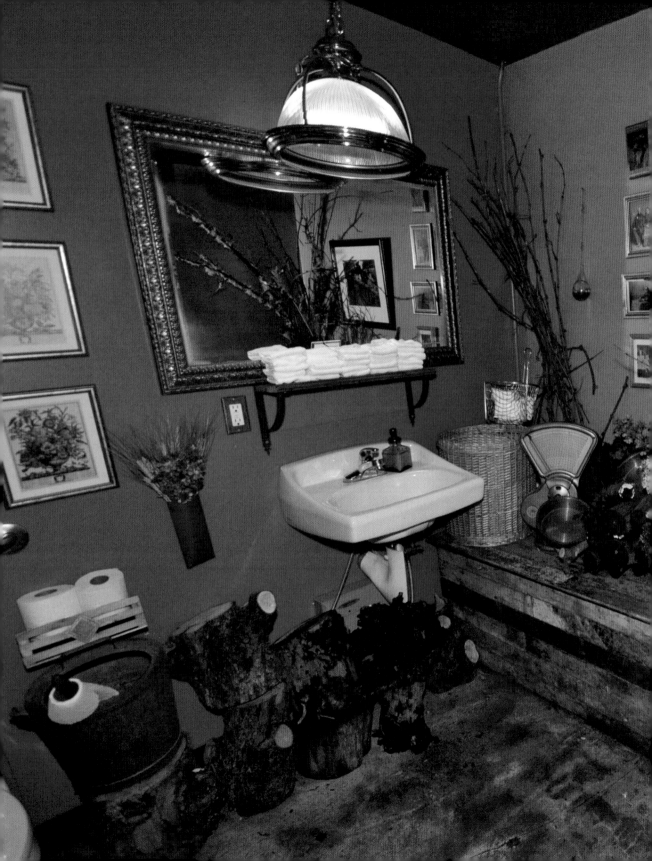

Foreword

When is a Bathroom Not Just a Bathroom

As a small boy, my family would dine at Benihana Restaurant. It was a showcase of flair and craftsmanship, part serious Japanese restaurant and part Asian American kitsch. While seated around the huge metal cooking surface, I would watch in awe as the chef prepared our dinner. Fast and precise, cooking multiple dishes at once, it was always a delicious spectacle. But for me, the magic of Benihana was not just in its food and its theatrical presentation, but above all, in its bathrooms. The men's room was small—just one urinal and a stall—painted an intense red with bright gold trim.

As a functioning bathroom, it was not much to behold, but the walls were covered with 8"x10" pictures of Benihana's founder, Rocky Aoki, either in a tuxedo or a speed boat racing outfit alongside some of Hollywood's finest. There were dozens of them and they told a tale of success—perhaps even excess—and American celebrity pop culture. Everyone from Loni Anderson to Sammy Davis, Jr. was there, and it was those photos that would take my basic human need to be in the bathroom and transport me to a world of '70s celebrity and paparazzi.

I use that story to illustrate the transformative power of a well-designed bathroom. On a basic level, both bathrooms and restaurants satisfy primal human needs. But like any art, each in and of itself can take the mundane and transmit it to ethereal heights.

This book serves to capture the restaurant bathroom as an objet d'art. Each offers its base purpose and yet, can also afford humanity an aesthetic experience that can serve multiple purposes beyond the basic: perhaps a sanctuary from a horrific first date, perhaps a place to reflect and digest the restaurant experience.

My own personal opinion would suggest that a well-designed bathroom should reflect the restaurant itself, perhaps even frame the ethos of the restaurant establishment. Either way, it should strive to diminish the profane aspect of our humanity and elevate us to see, seek, and share.

—Jason French, Owner of Ned Ludd

1967 W Burnside St.

Casa del Matador

WHEN I HEAR THE WORD "MATADOR," THE ADJECTIVES grace, skill, and valiance come to mind. Those characteristics are apparent when you step through the doors of Casa del Matador East Burnside. The interior borrows from classic Mexicana and Texan proportions. The hand-crafted wooden bar and iron accents are strong and graceful. The painted bull skulls that decorate the restaurant's walls are symbolic of the matador's brazen cunningness to willingly confront an animal that outweighs him by 80 times or more.

The Matador restaurant exhibits its own admirable skills with its innovative food, noteworthy drinks, and attentive service. Warm amber light from the custom centralized fireplace reflects the detailed stained glass work above the bar. The Matador is also a tequila bar, stocked with an extensive array of quality tequilas. The bartenders can and will educate you on this intoxicating, flammable liquid that, if you're not careful, will forever be referenced as the "I don't remember doing that!" drink.

Perhaps you sampled too many tequilas and decided to grab a decorative bull by its horn; maybe you spilled your drink hoisting yourself up on the bar in an effort to prove your own fearlessness—either way, make sure you find your way to the Latin-inspired bathrooms to freshen up.

Brushed-steel stall doors intermingle with hand-stained wood panels and glowing golden walls in the women's restroom. Bold red walls scream of bravado in the men's room. Ornate mirrors decorate and reflect, while flickering votive candles and flowers add flare to both spaces. The shape and feel of the cement vanities balance the feminine and masculine characteristics in these baños. These restrooms incarnate the audacious character of the traditional Spanish Matador.

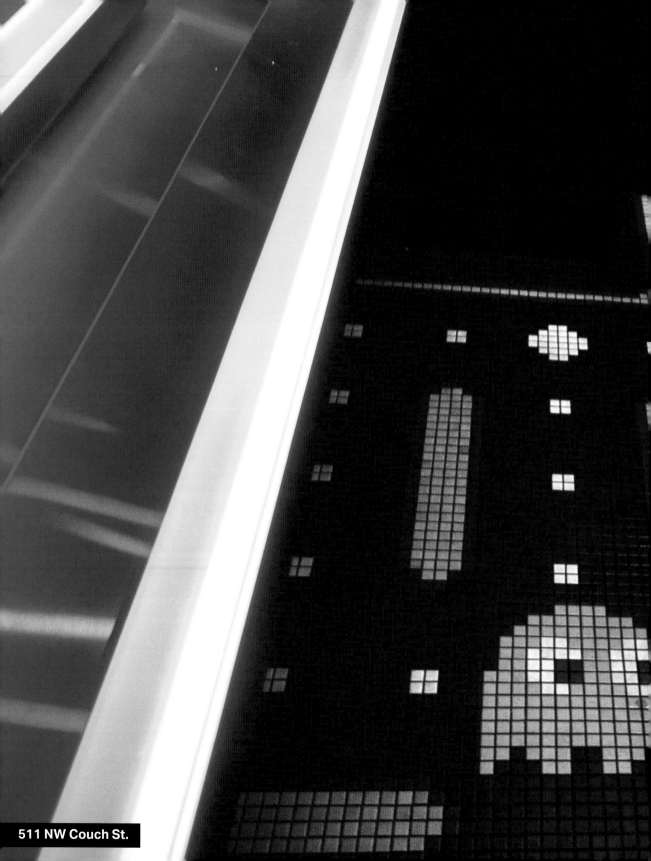

511 NW Couch St.

Ground Kontrol

LOVE VIDEO GAMES AND CLASSIC PINBALL GAMES? HAVE you ever wondered what it would be like to navigate your way through one of those games…from the inside? Stepping through the front doors of Ground Kontrol is like being transported into the landscape of your favorite video game. Warm blue lights illuminate the space, while the iconic pings, wawawa melody, and spastic sound of flippers create a nostalgic playlist for your ears.

Ground Kontrol was founded in 1999 by two record store employees who loved video games. In 2003, five lifelong pinball and video game fanatics took over the arcade, moved it to a bigger space, and made some graphic changes to the interior. Thankfully, the bathrooms were not overlooked in this transformation.

Pac-Man and Ms. Pac-Man were the natural choice for "his and her" video-themed bathrooms. Over 96,000 one-inch tiles of various colors were sourced and meticulously arranged to create the authentic Pac-Man and Ms. Pac-Man grid that spruces up the bathroom floors.

LED lighting outlines the sinks and fades through an array of colors, from green to blue to fuchsia. From the auto-sensing faucets, fixtures, and lighting, to the precise imagery, it's easy to imagine you've materialized onto a game grid—and bathrooms turned out to be the bonus level.

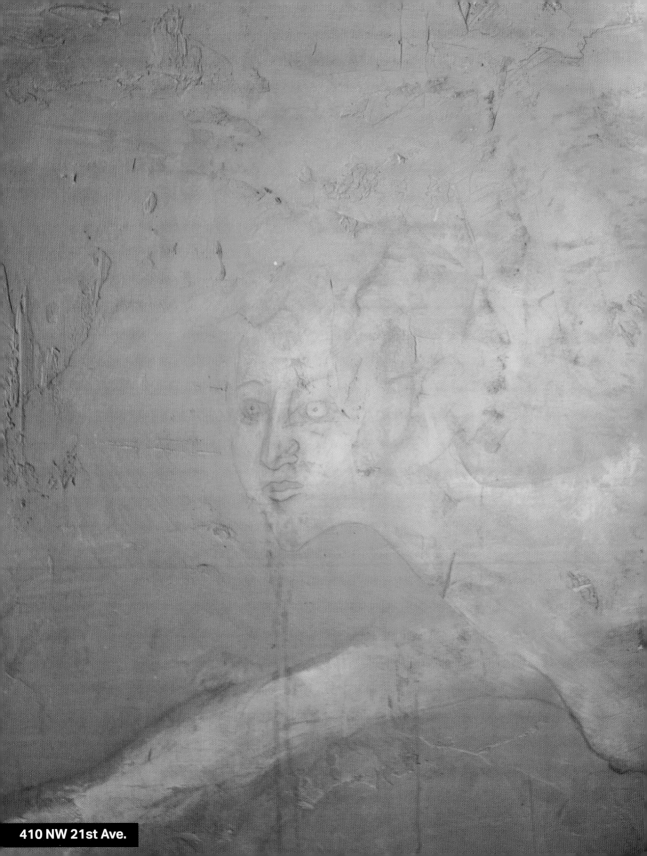

410 NW 21st Ave.

Bastas Trattoria

BASTAS TRATTORIA—A NEIGHBORHOOD FAVORITE FOR over 20 years—resides in the distinct A-frame building that sits on the corner of Northwest Glisan Street and 21st Avenue. The owner and chef, Marco Frattaroli, regards his family and his Italian heritage as his greatest influence. Born in Rome, Frattaroli grew up in both Italy and the United States, spending time in kitchens that were filled with fresh ingredients, creative thinking and a contagious passion that comes with authentic Italian cooking.

Lovingly hand-crafted meals are at the heart of this restaurant. An expert in charcuterie, Frattaroli was curing his own prosciuttos, salamis, and bresaola long before "house-made" became a buzz word. Not only are the ingredients local and organic at this charming Trattoria, the interior is also locally forged. The chairs were refurbished locally; the tables were designed and built a few blocks away; and salvaged barn wood was used to craft the tables, lending a rustic farmhouse chic to Bastas' interior.

Stroll through the wood-clad dining room down the hall to the second unisex restroom and behold the mysterious mermaid lady on the coral-colored fresco walls. She sprawls across three walls with such subtle grace that many patrons exit without ever noticing her. Perhaps she was painted in homage to the sea that supplies some of Frattaroli's favorite local razor clams and sardines, or maybe she's just a quirky artistic expression of the artist, who, incidentally, was once married to Frattaroli.

A handful of other inconspicuously painted, quirky images can be seen scattered up the tall peak of the A-frame wall, best seen from a seat at the bar—some may even make you blush. If you ask a bartender nicely, (s)he may even point them out to you. The authentic food and wine, local ingredients and décor are somehow even more delightful when served up in this peculiar A-frame building…

The Deschutes Brewery and Public House

THE DESCHUTES BREWERY AND PUBLIC HOUSE IN Portland is the first facility to open outside the brewery's hometown of Bend, Oregon. The 10,000 square foot building in Portland's Pearl District was formerly an auto body shop built in 1919. The interior has been meticulously redesigned by the renowned local firm, Emmons Architects. Its original wood-beamed ceiling remains undamaged.

Seeded throughout the interior spaces are massive old-growth, reclaimed timber beams salvaged from a variety of local projects, including the old Meier & Frank warehouse, which have materialized as mantelpieces, tables and the main bar. The painted scrollwork on the exterior of the building, that formerly advertised the makes of vehicles, now lists the brewery's diverse selection of beers.

The Deschutes Public House was crafted as a Northwest interpretation of a Scottish pub, but on a much larger scale. Intimate spaces were created using four timber-framed cubes that divide the space into smaller dining spaces. A wooden gate with scenes of Oregon wildlife, carved by renowned Sisters, Oregon chainsaw artist J. Chester Armstrong, encloses each smaller dining area.

The bathrooms at the Deschutes Pub were approached as an opportunity to make a statement. With the vast ceiling height and openness of the space, the plan was to source old large urinals, similar to those seen in P.J. Clark's, a famous old Irish Pub in Manhattan. After doing some research, the design team at Deschutes serendipitously tracked down a stunning double urinal in a salvage warehouse in Harlem.

It just so happens that P.J. Clark's had commissioned the porcelain piece because their old one was failing. The company that manufactured the replacement actually made two—the one in Deschutes is, incidentally, the second one. It has "P.J. Clark's" embossed on the upper corner of the right urinal: a source of pride for this unique establishment that manages to successfully pair rustic Oregon décor with an authentically Scottish heritage.*

* A few year back while in Manhattan, I befriended a lovely couple and, after hearing about this project, they offered to show me their favorite bathroom in town. They walked me right over to P.J. Clark's! Incidentally, this occurred before I became aware of this Portland porcelain connection. One of my most favorite outcomes of this book are the conversations and connections it has brought into my life!

210 NW 11th Ave.

Park Kitchen

Chef and Owner Scott Dolich picked a quaint location along the North end of the Park Blocks to open his restaurant in 2003. The name, Park Kitchen, was crafted to fit Scott's vision of a restaurant whose focus was inventive food prepared with integrity for the surrounding community whom he views as his extended family. Nowadays, with two successful Portland restaurants*, Scott spends his days sourcing the best ingredients in the northwest and training great cooks to meet his impeccable standards.

Like so many restaurants before them, Park Kitchen battled with paper towels clogging their toilets and wreaking havoc on the plumbing. People in Portland are known for their aptitude in creatively expressing themselves, and the staff at Park Kitchen is no exception. Fortunately, the office at Park Kitchen was adorned with nostalgic posters—this décor quickly inspired a clever solution to management's water-closet woes.

Jon Bon Jovi to the rescue! A poster featuring the musician switched residences from the office wall to the bathroom wall—with an added conversation bubble that reads, "Please don't flush paper towels in the toilet." Much to the delight of management, JBJ was a smash hit and not only stopped the clogged toilets, but created a little buzz of his own, as JBJ so often does.

That's not the only clever attribute that the bathrooms at Park Kitchen boast. Before the adjoining private dining space was acquired, the washrooms were in a shared hallway, and a nondescript door leading to the bathroom hall was visible to the dining room. In order to guide patrons to the restroom hallway, a local artist embellished the door leading to Park Kitchen's loos with a colorful (and demonstrative) "sign," featuring a bulldog lifting his leg to pee on a lamppost—a harmonious display considering the location of this restaurant and the dog-loving nature of Portlanders.

* Dolich also owns The Bent Brick, a contemporary tavern in Northwest Portland.

422 NW 8th Ave.

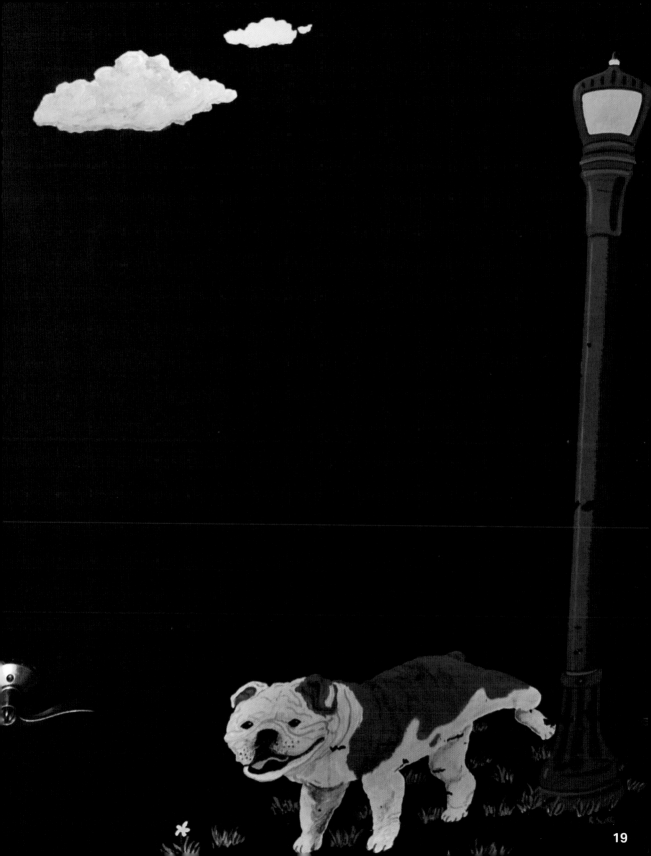

Old Town Pizza

OLD TOWN PIZZA IS LOCATED IN PORTLAND'S CHINATOWN; back in the 1800s, this area of town was known as the Old North End, a section of the city with a very questionable reputation. In 1880, the Merchant Hotel — the building in which Old Town Pizza currently resides — was built by two successful lumber barons and it catered to Portland's finest patrons.

In 1974, the Accuardi family opened Old Town Pizza in what was once the lobby of this historical hotel. The window where you place your pizza order is the original hotel reception desk, flanked by the original decorative cast-iron beam posts. Beneath your feet and below the floorboards of this space are the notorious Shanghai Tunnels. These tunnels connect Portland via underground pathways, and back in the day they were used to nab unsuspecting drunk sailors and transport them to ships waiting at the local dock. Oftentimes these vessels were destined for Shanghai*, and the kidnapped sailors would be forced to become slave laborers. Now these tunnels offer historical walking tours that detail their gritty and ghostly heritage.

Despite the Merchant Hotel's upper crust clientele, it was still known as a place that housed one of the oldest professions in the world: prostitution. As the legend goes, one of the "working girls," named Nina, was sold into the thriving white slave market of the time. Traveling missionaries, on a quest to clean up this area, convinced Nina to share information in exchange for freedom. Nina cooperated, but soon thereafter she was discovered dead after being thrown down the hotel's elevator shaft. Nina is reported to have never left the building. The remnants of the brick elevator shaft now serve as a "cozy" booth in the back of the restaurant. The booth has been characterized as sometimes feeling crowded, even when there is plenty of rump room.

The restaurant's transformation from the lobby of the Merchant Hotel created a bustling hangout for leaders in Portland's countercultural scene of the '70s. Actor Willem Dafoe could regularly be seen lounging on a couch in the mezzanine. Portland Trailblazer superstar, Bill Walton**, was known to ride his bike down from his house in the Northwest blocks to order his usual: a large vegetarian pizza and a pitcher of Henry's.

The bathrooms at each location reflect the character and eras in which they were created. The original location has walls decoupaged from stacks of vintage magazines found in the tunnels, and they reflect the faces and adverts of those times. The tight and awkward configuration of these water closets are in stark contrast to the modern and spacious amenities in the newer location on Northeast Martin Luther King Blvd.

Today the The Milne family keeps the Old Town Pizza legacy alive, nurturing a little piece of Portland's past while and adding new facets, like a brewery, for the next generation.

* This is where the term "to get 'shanghaied'" originated.

** Walton used to reside off of Northwest 23rd Avenue and has ties to one other Portland porcelain locations, Spirit of 77 (see p. 94).

226 NW Davis St.

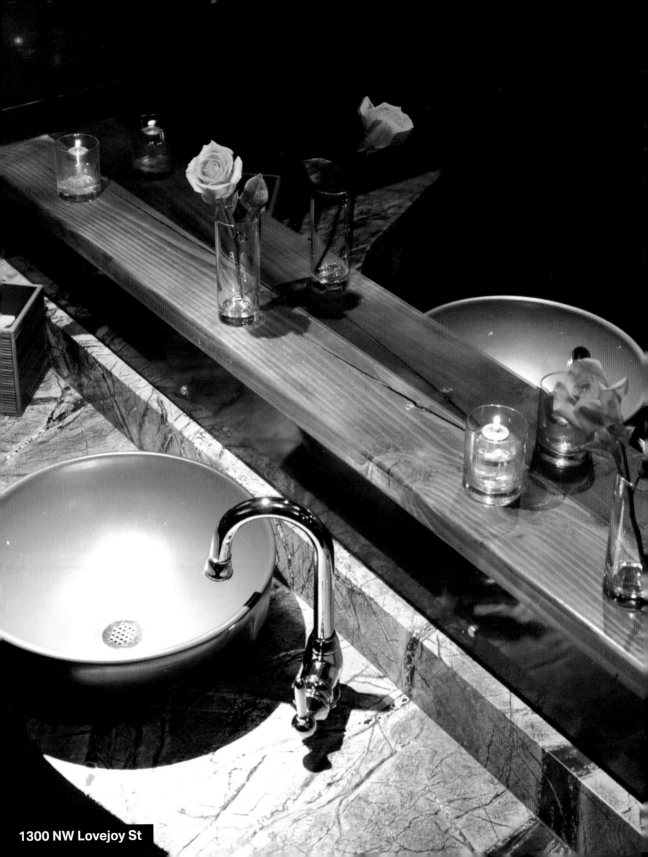
1300 NW Lovejoy St

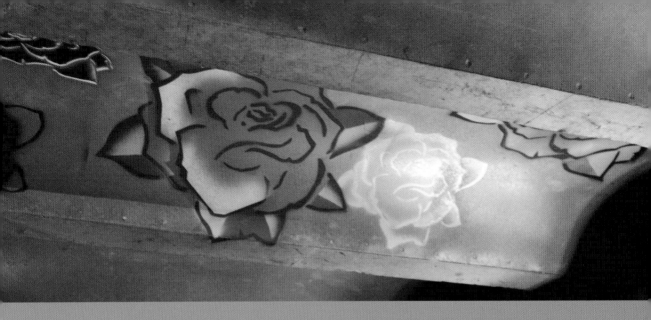

Pink Rose

VENTURE BELOW THE FLUORESCENT GLOW OF OFFICE MAX, down a set of concrete steps and through a narrow dark door, and you'll emerge into a warmly lit, pretty pink, concrete cocoon. Pink Rose is a restaurant nestled away in an unsuspecting location in The Pearl District.

When Pink Rose opened, owner Adan Heller wanted a name that would communicate both a neighborly hospitality for their community and their reverence of Portland. Pink Rose embodied just that. In the botanical world, pink roses signify: happiness, elegance, sweetness, and gratitude. And for Portland—officially nicknamed "The Rose City"— roses rule. So Pink Rose blossomed into a perfectly Portland neighborhood bar with elegance and a darn good burger. The small scratch kitchen serves locally sourced food, cooked to order and made with love.

At Pink Rose, the décor is just as alluring as the burgers. Down the stairs and into this subterranean restaurant's unique, cavernous space, you'll find a ceiling composed of a series of concaved, concrete channels. Roses have been airbrushed randomly on the concrete ceiling to soften the urban undertones of this space. The intimate room is aglow with warm pink lighting, and velvet curtains soften the dining room buzz. A balanced blend of black-and-white art, coupled with pops of color, hang from the walls. An upstairs patio, complete with pink umbrellas, make for an ideal spot for lovely summer late nights sipping wine and sampling plates, or grooving to the tunes of a local band playing al fresco. On chillier nights, cozy up in the "cave" below and feel as if you are in a hidden speakeasy with classic cocktails and a very laid back vibe.

Head to this pocket of a powder room with its tucked-away door and you'll note the elegant continuation of the restaurant's rose theme. Aggregate black stone floors add texture and style to this small space. A beautiful hand basin floats atop an irregularly shaped countertop, and walls of mirrors serve to dazzle and duplicate the rose décor in this pretty little powder room.

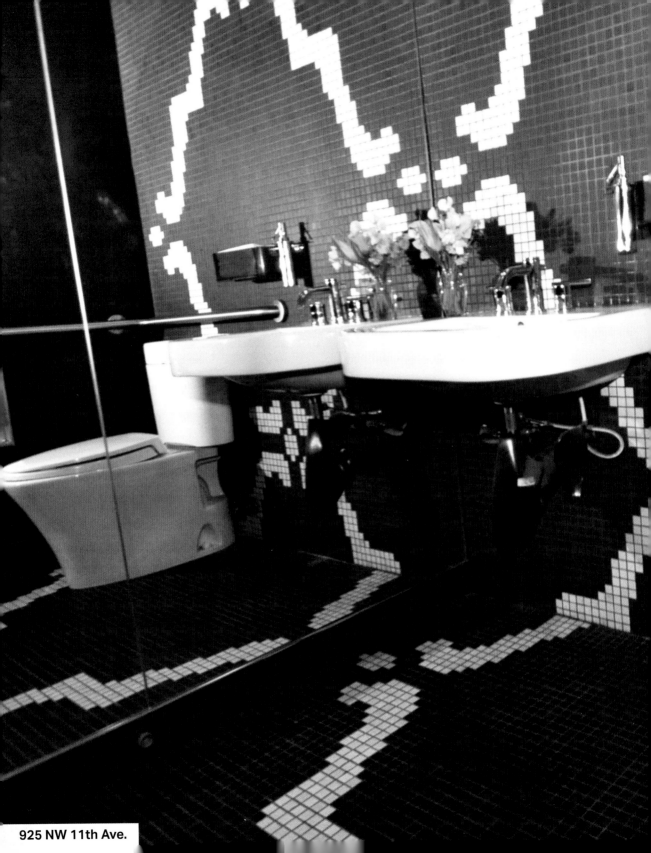

925 NW 11th Ave.

Olive or Twist

I PREFER OLIVES TO COMPLEMENT MY GIN. SAM FOWLER, the proprietor of Olive or Twist, is a fan of gin as well. The bar's name came out of a brainstorming session during which Fowler threw out a batch of martini-related terms; once olives were added as a garnish to the list of ideas, his search was over.

The pun on Dickens' famous novel is all the more appropriate considering the author himself was known to frequent gin bars. Nestled adjacent to Jamison Square, Olive or Twist has a clientele that ranges from young gin-novices and experienced martini-scholars to Pearlites and suburbanites. Whether you enjoy dinner or drinks and dessert, it's easy to feel comfortably indulgent in this classy yet casual space. Olive or Twist is as inviting and intoxicating as a gin martini.

The bathroom is a handsome extension of this distinctively elegant space. The space was small but Fowler was keenly aware that it deserved the same attention and finesse as the rest of the interior. A captivating black and white tile motif was beautifully crafted to add drama to this room. With two walls and a floor dressed up in this classic dynamic pattern, the opposite wall is mirrored to reflect, expand, and enhance this privy's pizzazz. The result: urban sophistication served up with your choice of an olive or twist.

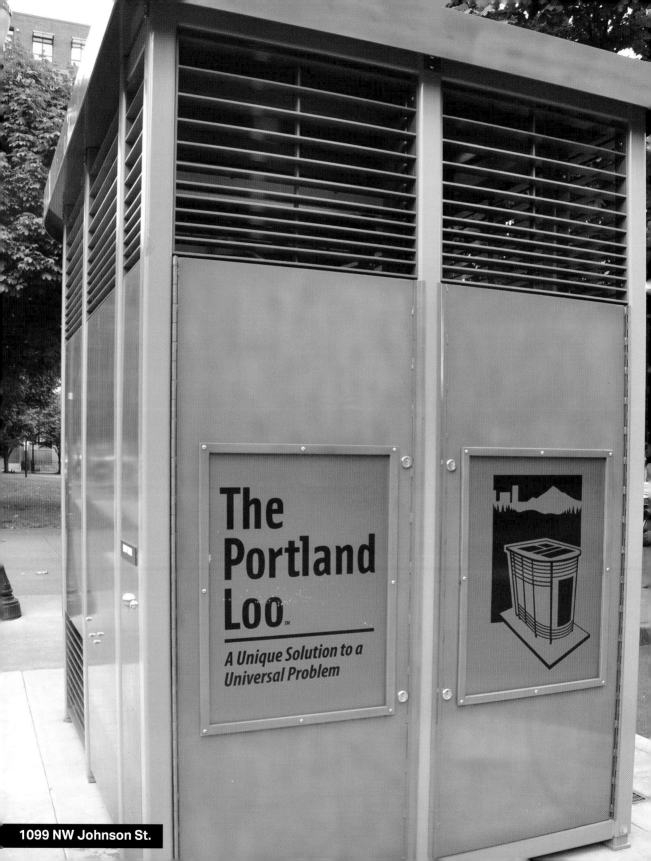

The Portland Loo™

A Unique Solution to a Universal Problem

1099 NW Johnson St.

The Portland Loo

PORTLAND AND PORTLANDERS ARE KNOWN FOR THEIR CRE-
ativity and ingenuity when it comes to design, envi-
ronmental impact, and urban living. The mention of
a public restroom tends to provoke repulsive looks
on people's faces, but Portland has tackled that issue
with an eye on aesthetics, safety, and environmental
consciousness. The Portland Loo is a six-foot by ten-
foot public restroom that is made from prison grade
steel to ensure its cleanliness and longevity.

This ingenious public restroom was specifically
designed to hold up well to the elements and its con-
struction allows the entire building to be disinfected
and sprayed down with ease. An anti-graffiti coating
covers all interior and exterior surfaces, providing a
force field against unsightly tags and other unsolic-
ited expressions of art or anger. The loo operates off
an electrical grid, powered entirely by solar-powered
LED fixtures.

The only water faucet is located on the outside
of the building, deterring lingering inside the loo.
Louvered slats are placed at levels that permit outsiders
to "see your trunk but not your junk;" this openness
also allows the sounds from within to be audible to
those close by, which promotes safety, albeit with the
very real chance of occasional gastrointestinal noise
pollution.

The Portland Loo has been installed in six neigh-
borhoods, from areas populated with street kids to
prime-real estate that is bustling with stay-at-home
moms with strollers and tots wearing designer kicks.
Its popularity and accolades have transcended the
borders of Portland and has piqued the interest of
city developers in San Diego, Vancouver, Houston,
Baltimore and Seattle.

Its first official export was installed November
2012, in Victoria, British Columbia, and won "The
Best Restroom in Canada" title sponsored by Cintas.
The Portland Loo is patented and has succeeded in
offering personal privacy, public access, and safety
while fulfilling a basic human necessity. It's a toilet
that is so popular, it has its own Facebook page, twit-
ter account, and blog!

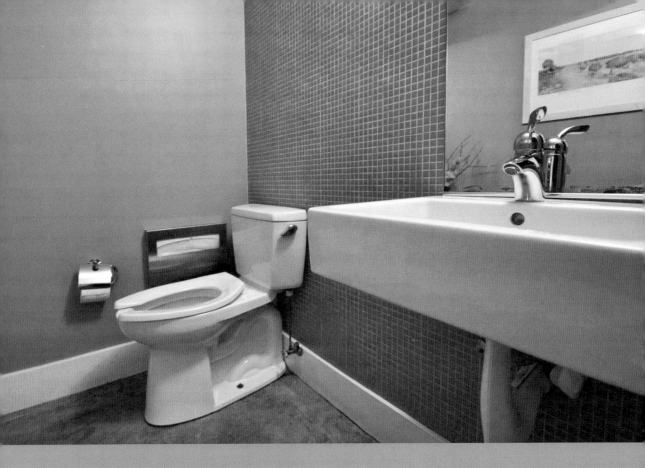

Bar Mingo

HOLDING ITS OWN ON NORTHWEST 21ST AVENUE, BAR Mingo emerged as an overflow space for its crowd-drawing big sister, Caffe Mingo. The space quickly stepped out from behind the shadows and took on a personality of its own, and Bar Mingo has now become known as a destination, and not just a pretty little layover.

Both establishments have garnered a reputation for dishes that please the palate with a consistency from the kitchen that is valued and appreciated. Traditional handmade pasta dishes earn the declarative, "delizioso!" followed by a sharp kiss to your fingertips. For owner Michael Cronan, this block of restaurants

on Northwest 21st is a family affair, starting at the corner with Serratto, moving onto Caffe Mingo, and continuing onward to Bar Mingo, each one named after a much loved and revered family member. Cronan is the quintessential old-style restaurateur, who offers authentic, simple food and terroir-based wine pairings with a generosity that makes customers feel welcomed.

Bar Mingo is swathed in warm tones of orange, cream and brown. Massive wooden barn doors, hung above the bar, add old world charm and a sexy masculinity to this space. The L-shaped interior creates two distinct dining areas; traditional tables and chairs occupy

807 NW 21st Ave.

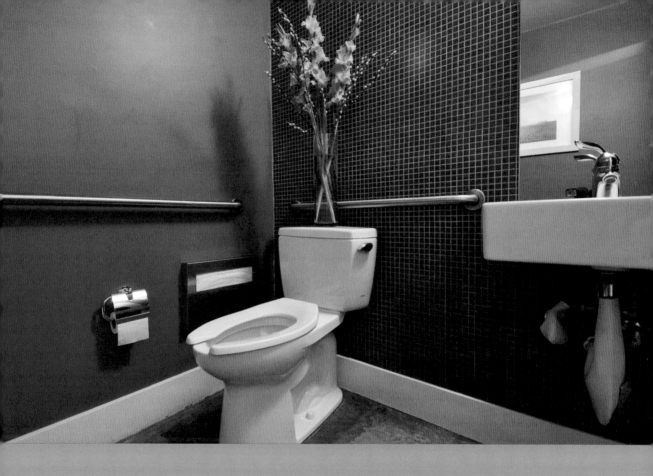

one while a generous "L" shaped banquet coupled with mini side tables creates another, more casually intimate dining space. Floor-to-ceiling gauzy curtains and ambient lighting contribute to, as one reviewer aptly put it, "the buzzy boozy" ambiance of this space.

Whether it's the booze, your small bladder, or just an escape from a bad date that necessitates a trip to these powder rooms, once there, you'll encounter modern restrooms that deliver a punch of monochromatic color accented with bold white fixtures that pop off the vibrant hue of the walls. The modish tone captured my attention and I became instantly smitten with the juicy orange intensity in the first bathroom.

My loo-love-affair intensified when I saw the blue color in the second bathroom. Orange is a color that appeals to the fun-loving nature of a person who likes a lively social environment. Blue is a color that appeals to a patient, sensitive, persevering, steadiness and wisdom.

The vastly opposing—yet perfectly complementary colors—reflect the balance of these adjacent establishments. Whether you're an orange-natured diner looking for a casual culinary experience, or a true-blue patron seeking solace in traditional settings, your options are one doorway apart and the dishes will delight no matter which door you choose.

Oven and Shaker

AN OVEN AND A SHAKER ARE ALL YOU NEED FOR ONE HELL of a tasty night! In case you're not familiar with the term, it roughly translates as a pizza topped with the perfect combination of delicious yumminess and a cocktail that quenches your thirst and seduces your palette—you'll find both here at Oven and Shaker. This modern urban saloon in the Pearl District pairs hearty Italian street food with ingredient-driven cocktails for a unique dining experience.

Oven and Shaker is the love child of four-time award-nominated James Beard chef Cathy Whims and verified cocktail veteran of the Northwest, Ryan Magarian. One has a passion for all things delicious and baked; the other has a passion for all things delicious and liquid. Throw in a restaurateur with a knack for success (local ChefStable founder Kurt Huffman)

and you'll be happily sedated for hours. Once the food and drink coma wear off, test your skills at recreating your newest liquid love from the recipe that is printed on the paper placemats. No need to distract and then swipe these placemats—Oven and Shaker gives them away!

Inside, reclaimed barn-wood lines the walls, while stainless steel glistens on the barstools and fixtures. The wood oven burns brightly in the corner and is said to be the Bentley of Italian wood ovens. The restaurant boasts a 45-foot-long wooden bar that is rumored to be the longest bar in Portland. The urban saloon vibe carries over to the restrooms with their warm and rustic reclaimed wood walls and farmhouse-style sinks. The bathrooms are sparse, but they complement the easy simplicity of the restaurant's urban saloon décor.

1134 NW Everett St.

Bamboo Sushi

ONE FISH, TWO FISH, RED FISH...GREEN FISH! Eco-conscious green fish, that is. That's exactly what you'll find at Bamboo Sushi, the first Marine Stewardship Council–certified sushi restaurant in the world.

Kristofor Lofgren is the founder and CEO of Bamboo Sushi. Calling himself an "ecopreneur," Lofgren admits that sushi restaurants can do more than just offer the sustainable options of farmed salmon and bluefin tuna. "They say they're letting customers choose. That's not the right way to go. You have to take a stand."

All the fish on Bamboo's menu can be traced back to sustainable sources and fishermen who use ethical practices, such as poll and troll, hook and line, and a Japanese harvesting method called ike jime. Bamboo has contracts with specific fishermen and exclusive rights to a number of different fishing vessels. They also adhere to strict guidelines pertaining to the way the fish are caught (delicately), bled (precisely), gutted (carefully), chilled and transported (hygienically). All of these methods promote the true concept of "green" seafood.

Dining at Bamboo means you're automatically putting your money where your mouth is. Consumer regeneration is a business model built on the idea that, yes, it is a great choice to consume sustainable seafood, but we also need to go one step further and think about how we're going to replenish that resource.

Unbeknownst to the guest dining at Bamboo Sushi (except for you, of course), a portion of the profit from your bill goes to fund conservation efforts. For every one fish Bamboo Sushi sells, they strive to put two fish back in the ocean. This is done through their partnerships with the Monterey Bay Aquarium, the Nature Conservancy, the World Wildlife Fund, and the Aspen Institute.

The atmosphere inside Bamboo Sushi is simple and warm, and the staff are trained with a huge emphasis on hospitality. The large mural of the tiger shark and its food chain was painted on-site by San Franciscan artist Jane Kim. The bathrooms are bamboo—sleek and modern, they too aim to educate. A sound system fills the single unisex bathroom with Japanese language lessons.

And if dining on delicious sushi, contributing to the efforts to advance sustainable seafood, and learning a phrase or two of Japanese isn't enough for you—you might consider topping off your night by adopting a shark! Just about everyone has a dog—be different, be memorable, be a shark owner! For $2,000, a shark will be tagged for research purposes, named by you, and you'll even be able to follow it on Google Earth! By the way, Bamboo requests you pay for the adopted shark in full before you choose the option to swim with your new adopted shark.*

*I made that last part up!

Cafe Nell

CAFE NELL IS A NEIGHBORHOOD GEM THAT MANY LOCALS consider to be their second family room—a place where family and friends gather to unwind or to celebrate! Tucked away from the bustling main arteries of NW 21st and NW 23rd Streets makes Cafe Nell feel all the more charming and intimate. Perfect fit for a restaurant that was lovingly named after the owner, Vanessa Preston's, mother Nell.

Preston herself is vibrant and gracious and can be seen interacting with her guests morning, noon and night. I've spent my fair share of hours at Nell, and it never fails—I go in for a drink and a bite, and I end up staying all night! What is it about Cafe Nell that makes it so addicting? It's the people! The interaction between the guests and staff quickly evolves into more of a friendship than a relationship based on service.

The bartenders at Cafe Nell are always mixing up tasty cocktails, and Cafe Nell even clinched the title Best Bloody Mary in Oregon as voted by the readers of Thrillist. This well loved drink aptly embodies Cafe Nell's vibe as: spicy, vibrant, full of surprises and will leave you feeling giddy.

The building itself was built in 1947 as a distribution facility for MGM Studios. Both Paramount and Universal Studios also had screening rooms on the same block. One tale told is that the building was used as a film processing facility. Another tale told is that it was a studio poster–distribution center. Aside from having a moviestar past, the building also has a bit of a naughty history to it as well.

Preston was a bit perplexed when, after pulling up three layers of carpeting and linoleum during renovations, they found grids of nail holes all over the place, as if the space had been cut up into a dozen little cubicles. One evening, a gentleman and his wife were dining in the restaurant, and he was able to shed light on that discovery. The gentleman was a retired lawyer who had represented employees of a massage parlor called the Kozy Kitten, which had inhabited the space during the '70s. This story makes sense of the grid like pattern on the floor but the name Kozy Kitten seems a little flirty for a "massage parlor."

The bathrooms have vintage tiny black and white tiles covering the floors. It's hard not to look good in these bathrooms, they offer that perfect ambient lighting created by lowwatt bulbs and votive candles giving your reflection a rosy hue. The pop of red on the modern industrial sconces along with the white subway set tile and the soft blue walls artfully combine to create bathrooms that are easy to linger in. And the smell—these bathrooms are some of the sweetest smelling bathrooms I've ever encountered!

1987 NW Kearney St.

Escape from New York Pizza

"WHEN THE MOON HITS YOUR EYE LIKE A BIG PIZZA PIE, that's amore." Dean Martin crooned about falling in love in his famous song, and what ranks nearly as high as love on an Italian American's list? Food. Especially pizza.

Opened in 1983, Escape from New York Pizza was the first pizza-by–the-slice shop to open in Portland. The walls, counters, ledges and nooks are full of New York memorabilia and personal photos, lending it a no-frills New York pizza shop vibe. No charades here—just the confidence that comes with knowing who they are and what they do well.

The same talent and spunk that goes into the pies at Escape from New York Pizza is showcased on the walls of the bathrooms. Mike Scheer is a local artist whose work has graced the album covers of Built to Spill and local Portland band, The Prids. The bathroom walls overflow with Scheer's images, both big and small. Each image fits within its own compartmentalized space, unrelated to one another apart from their surrealistic nature. These whimsical fantasies of flight and imagination include flying saucers, bumble bees with top hats walking on stilts, animated red dots, graphically detailed obscurities and—my favorite—the massive eye that peeks so realistically out at you from behind the porcelain commode, miming the words: "Eye see you peeing."

The shop's attitude is as authentic to New York as its pizza. The owners and staff at Escape from New York Pizza thoughtfully put together a set of "Frequently Asked Questions" that not only educates patrons, but also supplies them with a dose of raw and uncompromising New York attitude:

Q: Can I customize my slice?

A: No. That would compromise the integrity of an already perfect slice. If you want Pepperoni and Pineapple that bad, you can order a whole pie.

Q: PLEASE! IT'S FOR MY KID!

A: Your decision to breed does not negate the need for pizza integrity. Besides, you are a better parent than that!

Q: Do you have Ranch?

A: No, Ranch is for salads.

Q: Do you have salads?

A: No.

Q: Why not?

A: If Phil wanted to eat salads, he would have opened a lettuce stand.

622 NW 23rd Ave.

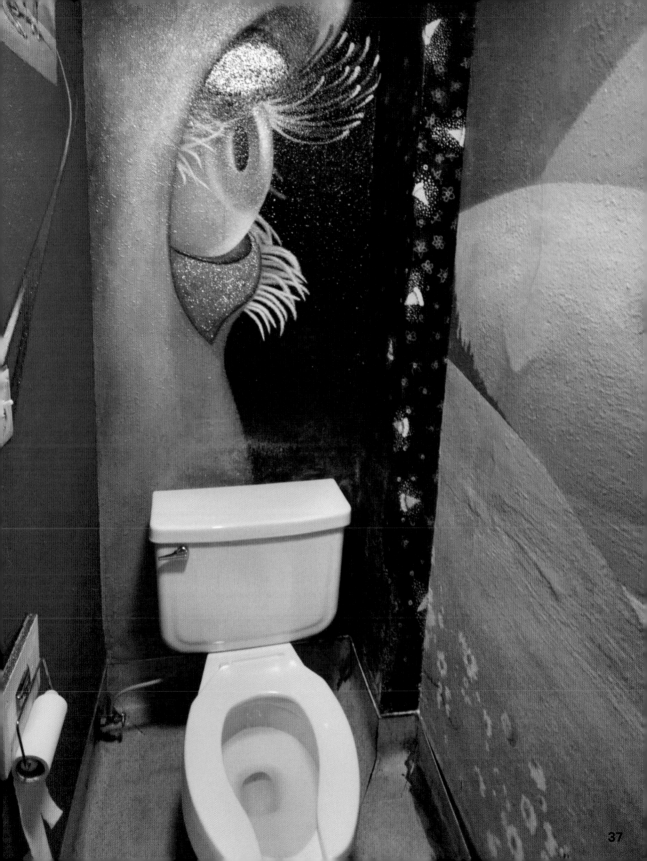

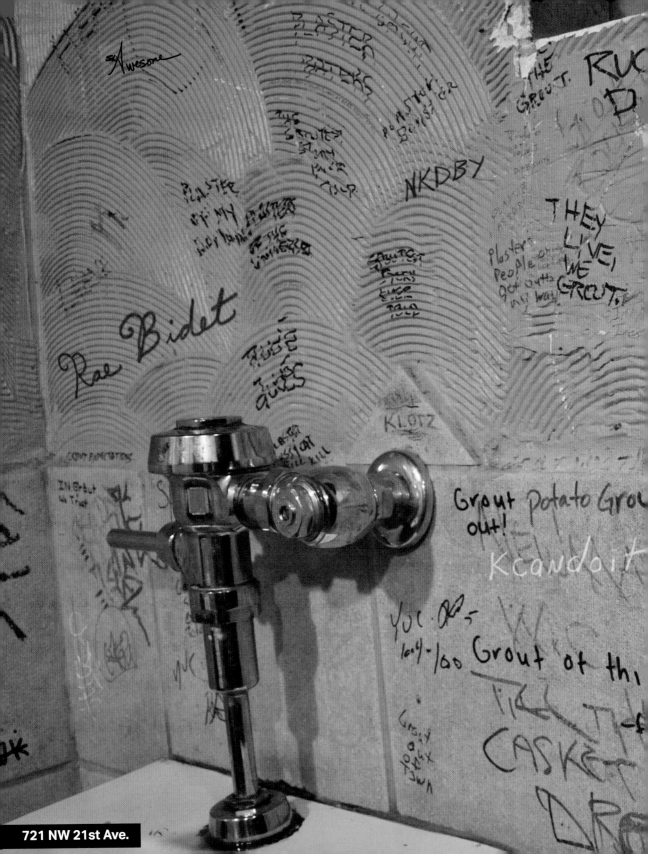

721 NW 21st Ave.

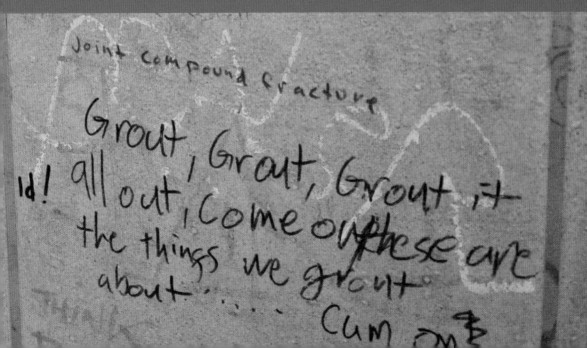

21st Avenue Bar and Grill

VANDALISM IS A WORTHY OPPONENT TO BAR OWNERS ON A shoestring budget. Combine that vandalism with just the right texture on a bathroom wall and a phenomenon is born.

Since 1998, 21st Avenue Bar and Grill, has been "the neighborhood joint" in Northwest Portland with a chameleon-like tendency to assume the personality of its clientele. The men's room is a comedic celebration of the word "grout" all over its tattered walls.

What began with the phrase "grout Scott!" in black sharpie many years ago, has been followed by other additions inspired by the initial mystery author. "Into the grout wide open," "grout at the devil," and "Mike Tyson's punch grout" are just a few among a litany of others that now decorate the bathroom. Fresh coats of paint over the grout quotes have only led to new contributions, much to the owner's chagrin.

No one seems to know who first penned "grout Scott" and initiated this enduring force, but it wasn't the staff. The loyal, tenured crew battled unsuccessfully, along with the ownership, to quell damage to their little establishment—they are now resigned to the fact that they will never grout-it-out. Those remarkable people, along with the bar's chill outdoor patio, tasty sliders and spoon-licking-good mac-n-cheese, are a worthy representation of Northwest 21st Avenue.

Five of the staff members here have been on the payroll for at least ten years, which is utterly commendable in this industry. In an era of expensive trends and attitudes, 21st Avenue Bar and Grill's friendly and unassuming consistency endures. Owner Matt Cordova has accepted his establishment's groutisms: though "frustrating and weird at times," he confesses, the 21st Avenue Bar is still "the 'groutest' place we'd ever want to own."

Departure

STATIONED ATOP THE HISTORICAL MEIER & FRANK Building, anchored to the 15th floor of the swanky Nines Hotel, sits the bar and restaurant, Departure. Stepping off the elevator, you are immediately aware of the "barnacle" low ceiling and tunnel- like hallway that guides you to the bar and main dining room. An ocean liner motif fills this intimate space, with a wooden smokestack-shaped structure jutting up over the bar, which features sailcloth panels and teak decking. Glancing out and up from your helm-bar seating, you'll see a 65-foot long "windshield" skylight revealing the horizon—a view that cannot be beat. Venture beyond the ocean liner's cabin, and you'll find two decks to choose from—both offer sweeping panoramic views of the City of Roses.

Departure features contemporary Asian cuisine that utilizes traditional techniques and ingredients from the kitchens of the Far East, paired with the seasonal,

local offerings of the Pacific Northwest. The cocktails complement the culinary voyage through Asia with spice-infused libations made with Northwest spirits and local, handcrafted sake.

During this continental voyage, be sure to walk your sea legs to the "head" of this boat. The bathrooms are tidy and sleek. Low lighting swathes a row of geometrically shaped, metal sinks while two mirrored walls flank each end of the bathroom, creating the illusion of an endless corridor. For all of the reflective surfaces in this space, it's amazing that it always looks so shipshape.

In a place with adventurous cuisine, exotic cocktails and sleek, inventive design, Departure is Portland's one-of-a-kind, sky-high retreat for bites, mingling, and gazing off into the horizon.

Shigezo Izakaya

SHIGEZO IS A TOKYO-BASED CHAIN WITH ITS FIRST U.S. venture on Portland's South Park Blocks. Not only does this restaurant offer your traditional Japanese cuisine—such as ramen, tempura and an extensive sushi bar selection—it also has a robata bar featuring grilled fish and vegetables.

Shigezo calls itself an "izakaya" (otherwise known as a pub) for good reason. Not only can you choose from a wide selection of sake, Shigezo has its own house cocktails such as the Godzilla, a Midori melon liqueur-based mix that puts you in a very convivial mood.*

While you're enjoying your Godzilla, it's not an uncommon sight to see groups of women whispering and giggling as they snake their way through the dining room headed towards the bathrooms. The ladies room at Shigezo has made quite a tingling impression on all those who have had the pleasure of using it. Why is that? Well, this toilet is not your everyday typical john. It is, however, a traditional Japanese "washlet."

This washlet can be thought of as the Rolls Royce of toilets (or a standby boyfriend when yours is out of town). With a heated seat, front wash, back wash, pressure and angle adjustments, it's surprising you ever see women at the tables in this restaurant!

* A very good point to iterate here is to avoid using "chin chin" when making a toast, since in Japanese this expression refers to the male genitals!

910 SW Salmon St.

401 SW 12th Ave.

Jake's Famous Crawfish

CONSIDERED ONE OF THE TOP SEAFOOD RESTAURANTS IN the nation, Jake's Famous Crawfish has been a Portland landmark for well over one hundred years. In 1920, Jake Freiman reeled in this seafood restaurant on the corner of Southwest 12th and Stark Street, added the Cajun crustacean to the menu, and officially cooked up Jake's Famous Crawfish. Bill McCormick and Doug Schmick's 1970 purchase of Jake's—as it's fondly nicknamed in town—spawned a restaurant empire that now includes over eighty restaurants and catering operations.

Despite its name in neon letters on the sign out front, crawfish isn't the only thing that draws the crowds into Jake's; it's the wide array of fresh seasonal seafood that is flown in daily. Think salmon roasted on a cedar plank, baked scallops, Oregon Dungeness crab, oysters on the half shell, and pan-fried Petrale sole. Jake's also exudes the old-school grandeur of a Pacific fish house with wood paneling, white table clothes, and waiters that execute superb service coupled with a time-honored spirit of hospitality.

Jake's is a well-mannered establishment with the exception of the boisterous bar. It is in this cheerful bar that you will find an energetic buzz reverberating in the air. A mixture of locals and tourists belly up to the bar for hand-shaken cocktails made with fresh-squeezed juices and a much-loved happy hour menu that won't leave you or your wallet skinny. It is also here that you will encounter a visual historical account of "the ways from back in the days." As you take in the beauty of the rich, dark, original wood bar, steer your eyes to the base of the bar below the brass foot rail.

The green and white tiled mosaic inset at your feet isn't just a decorative element: it is actually a trough—a urinal trough. Back in the day, the bar was a place for men to toss one back and chat with other men, since women rarely frequented bars. During that era, it wasn't considered unhygienic or grossly inappropriate to unzip your fly and relieve yourself right where you stood at the bar! I will safely assume the majority of us are happy we have made such strides with our bathroom etiquette; and to answer your next question: yes, I have been told that, from time to time, a "funny guy" will indeed try to unzip, whip, and whiz.*

* I have coined my own name for these men: "Jake-asses." Feel free to use it as you see fit.

Living Room Theaters

WHO DOESN'T LOVE TO WATCH MOVIES? PROBABLY THE SAME people who didn't buy this book because they are dull, dull people! How do you entice the everyday movie-goer to explore independent, foreign and classic films?

The Living Room Theaters answers that question by completely reinventing the movie theater experience with oversized comfy chairs, reasonably-priced candy and snacks, a full menu—and alcohol. Enjoy a pre-show meal in the lounge or saunter up to the European-style bar and enjoy a cocktail, beer, or glass

of bubbly before the show. If you're having doubts about your film choice, order a drink to accompany you into the show. If you are already a fan, order a drink anyway and take a seat, relax and enjoy the beauty and comfort of this cinematic experience.

The Living Room Theaters preview a diverse array of film genres, including emerging local talent, film festival nominees, and even skype chats with directors. Oh my—I was so caught up in the foreign eccentricity of the place, I almost forgot about their clever

bathrooms! The facilities are spacious and elegant with expansive granite sinks and a tasteful color palette. The delightful deviation here comes while washing your hands or reapplying your lipstick.

The mirrors in the women's room are off-center to those hung in the adjacent men's room, with the recessed negative space between the two mirrors actually being two-way mirrors, creating a peek-a-boo effect between the men and women's bathroom vanities. So be mindful of what you pick, adjust or reapply, because

it's not your own private Idaho. On the flip side, it can be seen as very avant-garde. It's almost as though The Living Room Theaters has set the scene for your own foreign film scenario, in which you explore the timeless theme of "boy sees girl in movie theater; girl notices boy in concession line; independently they go to the restroom, and to their surprise, their eyes connect briefly while washing their hands; back in the theater they look desperately for one another"…and, well, you know how that story goes…

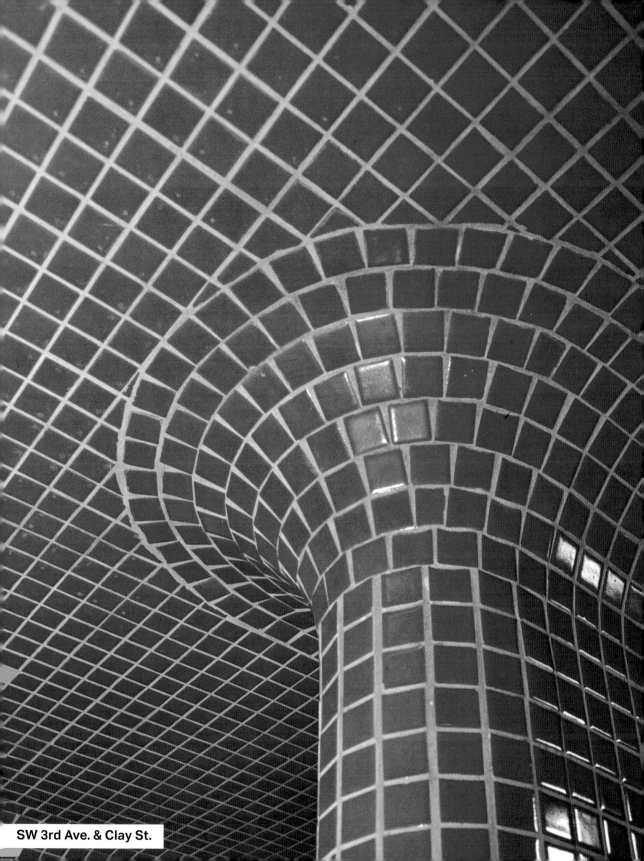

SW 3rd Ave. & Clay St.

The Orange Public Restroom

I WOULD BE REMISS NOT TO HIGHLIGHT THIS BATHROOM —after all, this public bathroom has reviews on Yelp, pictures featured on flickr, and has its location and hours listed on two other websites. Located on Southwest 3rd Avenue and Clay Street, next to the cascading Keller Fountains*, this public restroom has been appropriately labeled the "Orange Public Restroom," and for good reason.

Tiny orange tiles dominate this restroom from ceiling to floor. Instead of the walls creating sharp right angles with the floor and ceiling, they unfurl into gracefully rounded curves that give this room an undulating feel. One reviewer likened it to the concept of being "devoured by a snake" as you wind your way past the smooth twists, turns, and curves of its internal pathways. To me, this bathroom holds less doom and gloom than some reviewers purport—I liken it to a brightly colored, slick waterslide with rippling curves that propel you down its track. To each his own interpretation of this orange-a-licious bathroom—just make sure you pop in for a peek so you can experience this acclaimed Portland potty for yourself.

* These fountains reflect the beauty of the art that is performed within the Keller Auditorium, and also provide a refreshing and fun place to frolic when Portland's temperatures heat up.

Urban Farmer

THE NAME URBAN FARMER IS ILLUSTRATIVE OF THIS establishment's ambiance, food and location. This restaurant is located on the lobby level of the posh Nines Hotel.* Stepping off the elevators on the eighth-floor reception level is like walking into a swanky modern art gallery. Bold, abstract, life-size statues are waiting in the wings, as if they're expecting their friends to ascend from the hotel's classically chic rooms. Beyond the registration desks, you'll find a magnificent, airy atrium, bathed in natural light that pours down from the glass ceiling. Intimately grouped clusters of seating are scattered throughout the space. Tall plumes of soft grasses and low stone walls delineate Urban Farmer from the shared lobby area space. The atmosphere is a balance of charm and rustic farmhouse elements, juxtaposed with the audacious structure of mid-20th century modernism. Despite its contemporary design, this modern Portland Steakhouse grounds itself in the philosophy of farm-to-table dining.

525 SW Morrison St.

Pampered is definitely how one feels dining here and the powder room is a natural extension of this luxurious vibe. The high ceilings, tufted leather lounging ottoman, and an illuminated vanity flanked with a black lacey cut-out pattern gives this ladies lounge a glamorous feel. Cotton hand towels and aromatic counter products add to the age-old art of reapplying your lipstick in between courses.

Whether you are checking in to the Nines or checking out Urban Farmer, stepping beyond the registration desk is an experience that offers up a unique coupling of Portland's architectural history with contemporary Northwest luxury.

* The Nines Hotel rests atop the landmark Meier & Frank Building and pays tribute to the edifice's historical past. This fifteen-story, white-glazed terra cotta building was erected in 1909 as the flagship store and headquarters for Meier & Frank, which was once credited as the largest retailer west of the Mississippi. This iconic Portland monument housed the first escalator installation on the west coast and, incidentally, served as Clark Gable's place of employment prior to his illustrious acting career.

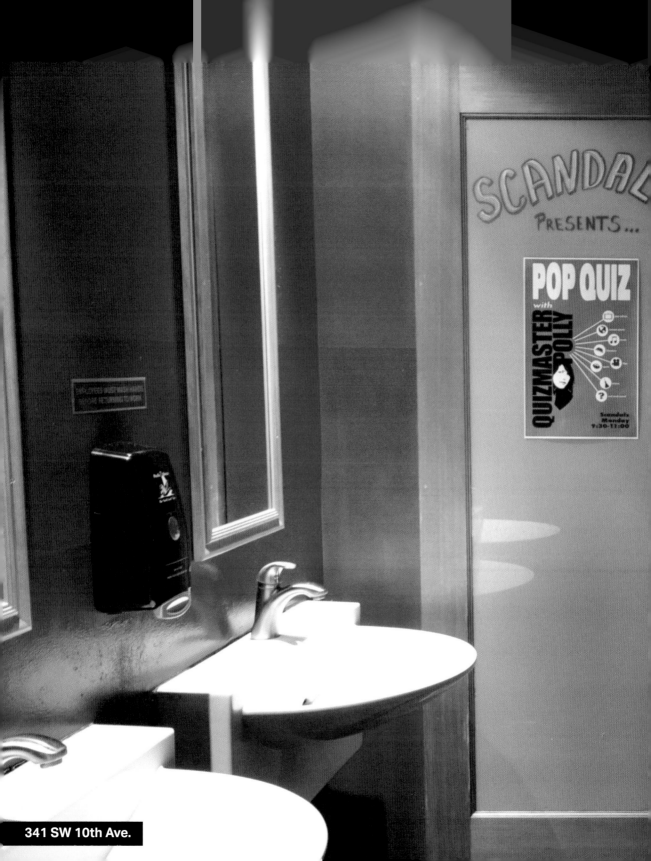

341 SW 10th Ave.

Scandals

ONE OF PORTLAND'S MOST ESTABLISHED GAY BARS, Scandals is located in the original "Pink Triangle" section of downtown Portland on Southwest Stark Street and Southwest 12th Street. When Scandals opened in the late '70s, the bar's name held a more literal interpretation; today, with floor to ceiling windows that let light and the curious onlooker in, Scandals is a very open and approachable gathering place. It is also one of the few places in Portland that boasts a winter patio. The patio's "living room" feel makes for a great place to drink and watch the world go by, get caught up in conversation, or simply hold your own court! Recently one Scandals owner, David Fones, donated his twenty-year-old deck so it could be repurposed into additional bench seating for this proudly open and out patio.

Not only is Scandals a great place to meet friends for karaoke, trivia or to dance—it's also a bar dedicated to its community. During Pride weekend, the sidewalk in front of Scandals is fenced off and transformed into an amazing block party that spans the entire weekend. Proceeds from the party go directly to the Cascade AIDS Project, which works to keep AIDS testing in local CAP bars free.

Scandals is a place where all walks of life are welcomed: laughter and memorable one-liners decorate every corner, and that communal essence carries over into their unisex bathroom. Painted a fiery lipstick red, the room features bright white modern sinks and gold-framed mirrors, evoking a sexy sophisticated elegance. With only a partition (aptly emblazoned with the word "Scandals") separating the commode from the sinks and the modern urinals, some patrons may find it quite "scandalous" to use the lavatory knowing others are just steps away.

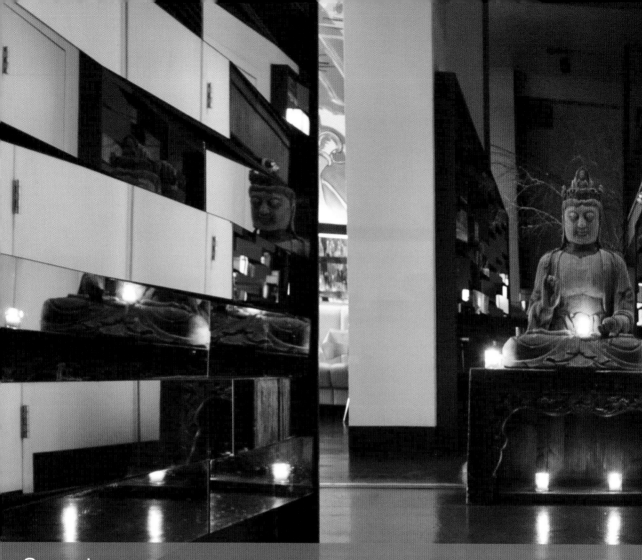

Saucebox

THE OFFICIAL DEFINITION OF "SAUCEBOX" IS A SAUCY, IMPU-
dent person, especially a pert child. Walking into this
Bruce Carey restaurant, you won't find many pert chil-
dren; instead, what you'll find is a space that is bold,
sexy and alluring. Sure, it gives off a bit of brazenness
in its confidence as a hip, urban Portland spot, but cer-
tainly not in a childish way. The modern and clean-lined
interior creates a beautiful canvas for colorful Pan-Asian
dishes like the five-spiced cauliflower, green papaya
salad, and sweet potato spring rolls. Saucebox, which
opened in 1995, pioneered Portland's DJ-cafe move-
ment, and it's still known for the variety of electronic
house music, with DJ's spinning music five nights a
week. House music on the turntables and house-infused
specialty cocktails—such as "The kickboxer" or "The
Diablo"—set the stage for a fabulous evening. The en-
ergetic vibe of the staff plays off well with the cool and
clever customers who frequent this hot spot.

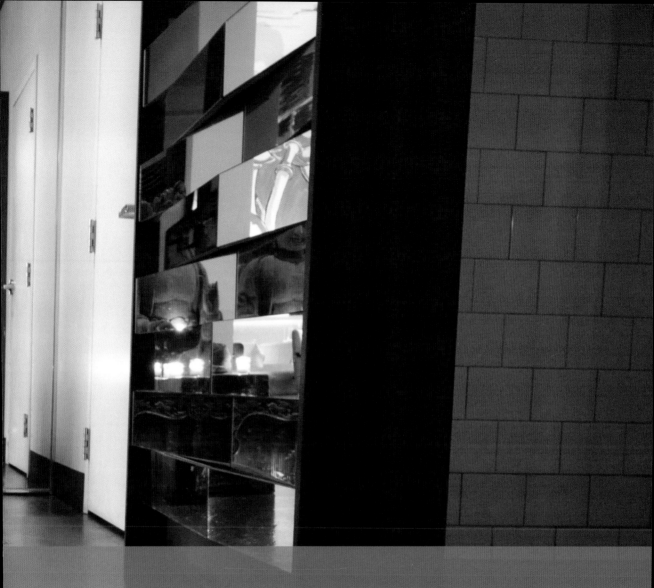

Mirrors that ebb and flow into one another create a basket-weave effect along the hallway that leads to the bathrooms. A Buddha sits philosophically at the end of the hallway, surrounded by votive candles, creating a sense of transcendence. An interruption in the mirrored hallway introduces this ambiguous male/female bathroom entrance: to the left, the ladies room, and to the right, the gents'. A beautifully massive flower arrangement sitting atop the faucet at the communal sink is guaranteed to draw your attention, diffusing its aromatic scent throughout this alcove. The real fun ensues at the crescent-shaped communal sink; if you happen to be in this dimly lit alcove with someone flirt-worthy (and hygienic), perhaps you'll slyly brush hands while washing— how saucy of you!

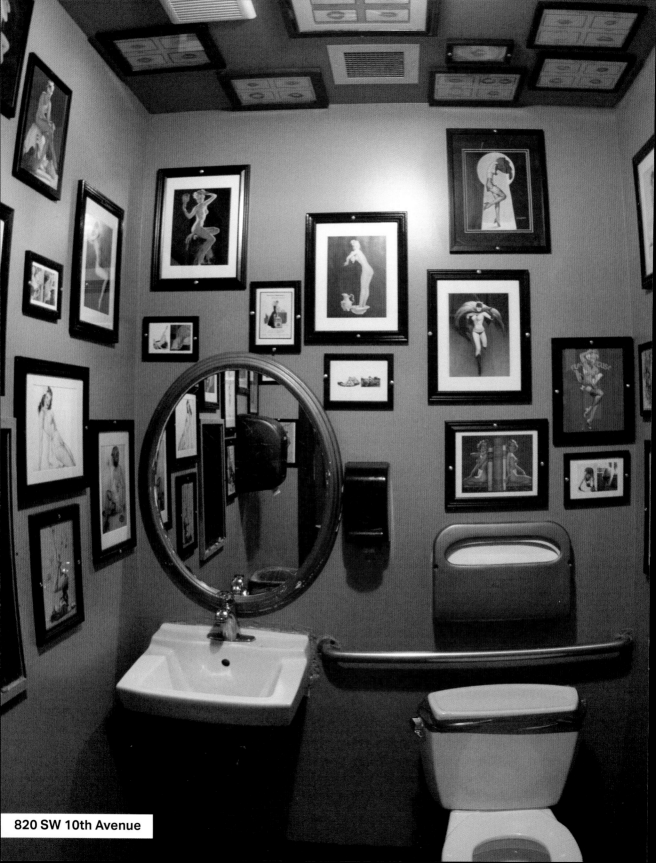

820 SW 10th Avenue

Virginia Cafe

THE HISTORY OF THE VIRGINIA CAFE (VC)* CAN BE TRACED back as far as 1906. With a hundred years in the making, the VC is as much a representation of Portland as our iconic bridges and roses.

Over the past hundred years the VC has had to make a few moves. The most memorable of those moves happened in 2008. Amidst the transformation of the old Willamette Week classifieds offices, owners Bob Rice and Peter Goforth were determined to maintain the feel of the VC. Many of the old fixtures and booths made the journey to the new location, thanks to patrons' help, so the story goes:

February 25th, 2008 started like every other day had on Park Avenue, with one exception: it was moving day for the Virginia Cafe. With our home on Park Avenue still open for business for one last day, work was escalating to a fever pitch to get the new place open on 10th Avenue. The anticipation for the move was mounting. At 4:33pm family, friends and longtime patrons of the Virginia Cafe picked up their bar stools and began the bar stool crawl to 10th Avenue.*

One booth even found a home at the Oregon Historical Society.

The VC may be dark inside, but it's anything but dim when it comes to character. The walls are decorated with historic pictures of the bar and its surrounding neighborhoods. Framed handwritten memories of the VC from longtime patrons dot the wall space between booths.

Years' worth of talented napkin art line the hallway walls leading to the bathrooms, where some of the city's best lips can be seen!

In the '80s, the VC decided a fun way to celebrate Valentine's Day was to put those luscious lips on display—on a napkin! Thus started the Lip Print Contest. Categories are: Size, Color, Shape, Allure, and the newest category: Hot Mess. The current champion lip prints are framed and hung with honor on the front of the women's restroom door. Inside the women's loo are walls plastered with plaques of past winners' lips mixed with classic pinup prints.

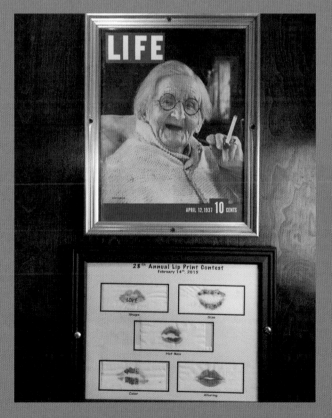

*Check out the Virginia Cafe website for a more detailed and rich historical review.

Voodoo Doughnut

SINCE 2003, VOODOO DOUGHNUT HAS BEEN MAKING SOME of the tastiest doughnuts in Portland and generating world-wide recognition. Voodoo now has two stores in Portland and one in Eugene. Each store has its own zany vibe that embodies the spirit of their doughnuts. Pink is the dominant color in these shops, with velvet paintings of Kenny Rogers, Isaac Hayes, and Conan O'Brian. Pinball machines, a photo booth, and a bubble hockey game add to the kitsch that decorates these doughnut dugouts.

So what exactly is all the fuss about? A sampling of some of the odd, mildly offensive, but always tasty creations: the famous "Bacon Maple Bar" (a raised doughnut smothered with maple syrup glaze, and topped with two crisp bacon strips); the "Memphis Mafia" (a banana fritter with chocolate frosting, peanut butter, peanuts, and chocolate chips); and the illustrious "Cock-N-Balls" (three raised yeast doughnuts artistically positioned to resemble "you know what," which are then triple filled with Bavarian cream, and finally topped with chocolate frosting).

Stepping away from the revolving glass showcase of doughnut creations and looking into the loo at Voodoo Doughnut Too, you will find "The Lady of the Loo," a papier-mâché woman wearing a mask, who is having her hair done by flying monkeys in preparation to meet the Voodoo King. And, of course, she has a doughnut where her heart should be.*

The vibrant mural that covers the surrounding walls is an elaborate masterpiece created by layers of duct-tape that have been precisely cut to reveal an energetic scene featuring tribal dancers and stunning Carnival characters. The bathroom at the original Voodoo has an equally fabulous '70s mod duct-tape theme adorning the walls (think "Mars-Man meets disco porn"). Ms. Mona Superhero is the local artist behind these original duct-tape murals, both of which make it hard not to linger in these loos.

And if Voodoo, doughnuts, and duct tape weren't enough of a wow factor, let's throw in matrimony! You can get legally married at any of the Voodoo Doughnut locations. Already married? Don't fret! You can renew your vows under the holy doughnut.

* Terry Hallett-Lyman masterminded "The Lady of the Loo" and created the bust of this statue with the help of friend and Suicide Girl, Rachael Reckless.

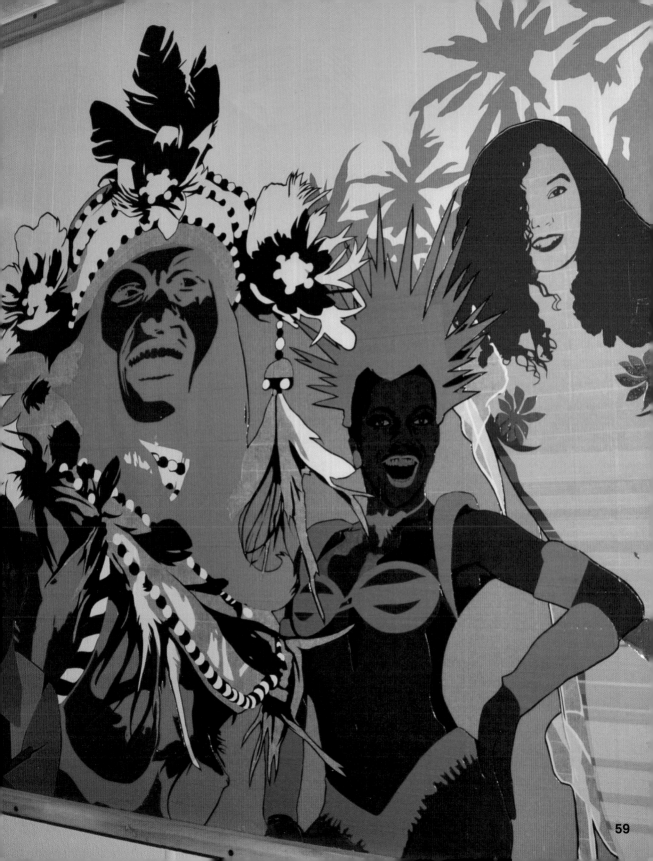

COZIED UP NEXT TO THE UBER-HIP ACE HOTEL ON Southwest Stark Street is the handsome urban coffee-house known as Stumptown Coffee Roasters. What started out in 1999 as a single roaster's revolutionary idea to brew the best tasting cup of coffee quickly took Portland by caffeine storm and has since spread across the country to New York, Seattle and Los Angeles. Carefully-chosen coffee beans are expertly roasted by coffee artisans producing a well-balanced and fla-vorful cup of Joe that satisfies even the finickiest of coffee aficionados.

At first sight the line of loyal Stumptown devotees can be intimidating, but it's worth the wait. These Baristas, with ink on their arms and vintage clothes on their backs, know their brews and can break down a coffee's attributes just like a sommelier can speak of the characteristics of a fine wine. Counter seating at the front window hosts a bevy of colorful people-watching opportunities. A doorway towards the back left opens up to the lobby of the Ace Hotel and super-soft-seating on their ultra suede couches, along with a vintage photobooth to capture those "before and after" caffeine glamor shots.

The single unisex lavatory is another innovative ex-ample of encountering uncommon, imaginative ideas within the confines of a commonplace necessity. Floor to ceiling mini, round subway set tiles parade across the walls all the way down to the gracefully curved corners of the room. A smart trim porcelain sink with an equally smart wall-mounted faucet catches your eye, while dark, smoky mirrors frame the room. If you should happen to take a seat on the porcelain throne you will notice a slight reddish tint illuminating the dark mirrors.

Images that weren't present at first glance subtly come to the surface in a double-exposed manner, re-vealing moose, deer, squirrels, rabbits, evergreen trees and even the Pacific Northwest's infamous Sasquatch.

At first glimpse these happy wilderness critters ap-pear to be frolicking within the mirror's surface, but some say they are doing more than frolicking. Want a definitive answer? Take a close-up peek for yourself.*

* Have an informed and/or imaginative explanation depicting just what those woodland creatures are up to ? Post it on Portland's

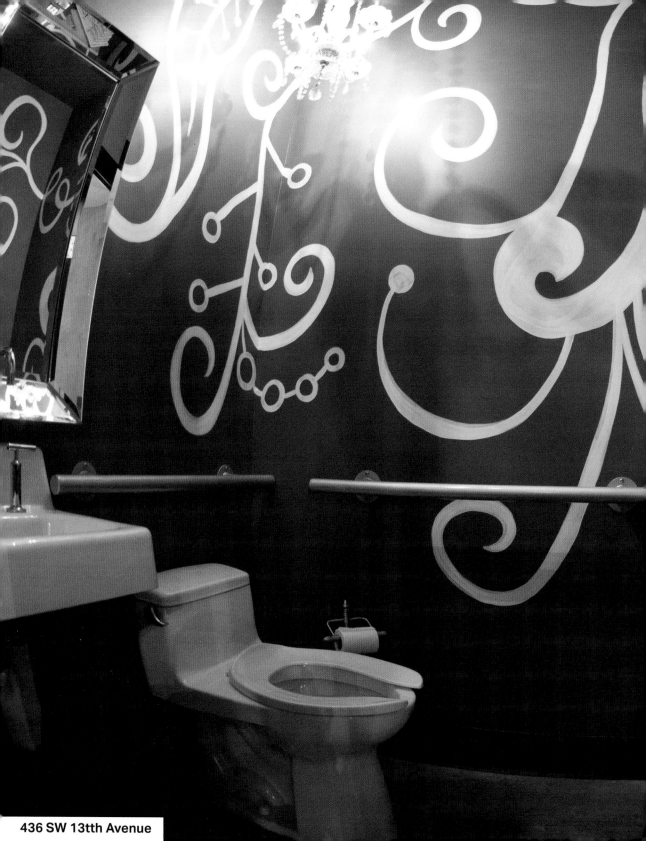

436 SW 13tth Avenue

Prima Salon

PRIMA: A STRONG WORD ASSOCIATED WITH LEADERSHIP, original and having the highest quality and value. That's exactly how the staff at Prima want you to feel when you leave their salon. Do they expect you to know you've just reduced your carbon footprint on Portland in the same length of time it takes to process highlights or receive your polished look? No, but you'll have done just that by stepping into this salon. Prima is an eco-friendly salon in one of Portland's leading energy-efficient buildings, the Indigo Building—frequently referred as "the one with the wind turbines on top."

Jennifer Webb, the owner of Prima Salon, not only has a passion for making people look and feel the best they can, but she also had the vision to bring together a salon full of talented artists who want to make you feel and look glamorous. Whether you're in need of a cut, color, wax, tan or a special look for a special evening; the staff at Prima wants you to walk out of their salon feeling a little taller, and perhaps even a little sassier.

Webb believes that the bathroom is an extension of your environment. Her goal in creating the bathroom at Prima was to make you feel as if you were a princess sitting on her throne. Gretchen Wright is the talented muralist who painted the bathroom. The dark gray walls are covered in a fresco of curving, curling, fluid lines that mimic the gracefulness and curves of a woman. The mirrored furniture and crystal chandelier add opulence to the space. And the delicious-smelling lotions and potions available—along with the soft, folded hand towels—contribute to the feeling of pampering in this lovely loo.

Little Bird Bistro

LITTLE BIRD BISTRO IS THE SWEET PETITE SIBLING OF THE well-known, highly coveted Le Pigeon located on Portland's east side. Traditional country French fare is the name of the game at downtown Portland's Little Bird Bistro. Owners Andrew Fortgang, an accomplished sommelier, and Gabriel Rucker, the recipient of multiple James Beard Awards, have created a popular—and delicious—nesting spot for Portlanders.

The menu at Little Bird, although inspired by the dishes served at Le Pigeon, offers a much more approachable take on French cuisine—at a friendlier price point, too. From the outside, the restaurant seamlessly blends into the flat, stone facade of the office building where it's nestled. A small wooden sign is sweetly perched above the doorway indicating its location. Inside, the space feels expansive and inviting with walls bathed in a soft greenish-blue tone. Live plants scattered throughout the space add shades of green that contribute a soothing and fresh vibe, while red banquette booths add richness. The mezzanine, with its wrought-iron railing and tin ceiling, draws diners' eyes up and sets the tone for an enchanting evening.

Little Bird Bistro isn't just for a night out; it's also perfect for a lunch that doesn't feel rushed, yet doesn't keep you sitting beyond your lunch hour. It's ideal for toasting the end of your day. Plus, you can start that celebration as early as 2:30 p.m. here with Little Bird's Early/Late menu. And it's also worth noting: their sought-after burger, offered in limited quantities at Le Pigeon, is served in limitless supply at Little Bird Bistro!

After saying, "*Oui, oui*," to the delightful desserts offered, be sure to excuse yourself from the table for a different kind of wee-wee.* The bathroom at Little Bird mirrors the homey elegance of the restaurant. Robin's egg–blue walls with mounted antlers serve as the focal point. Warm wood floors and a sturdy wooden table with a tablescape of greenery and a globe are details that extend the ambiance from the dining room to the powder room…perhaps the globe is there to serve as a reminder of all the places you can go.**

*A bathroom pun.

**Yes, that was another fully intentional pun.

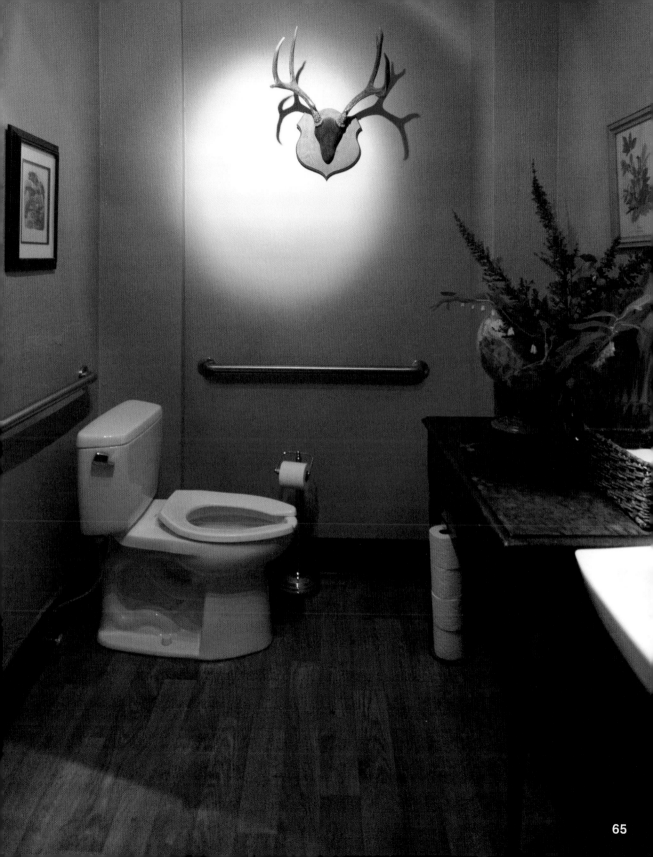

Doug Fir

THE DOUG FIR IS A MODERN, FUNKY LOG CABIN LOCATED on East Burnside, full of hipsters, strong drinks, and some fantastic music. Take a seat in the restaurant upstairs, saddle up at the bar, settle in on a couch by the fireplace, or sit outdoors on the patio where bamboo and fire pits intermingle to create an urban oasis. From the outside, The Doug Fir looks like a golden, glowing log cabin from the 1970s (think retro, not ramshackle).

Inside, the rustic lumberjack vibe continues with massive log walls, warm lighting, and unexpected modern touches, like a glass moose head mounted on the wall. Although log cabins traditionally aren't known for basements, the Doug Fir has a rockin' one! The Lounge hosts cutting edge concerts, and offers an intimate musical experience from every vantage point on the floor. Seven nights a week, a broad spectrum of musical genres can be heard here with ticket prices that befit a log cabin lifestyle.

The Doug Fir loo was the one that wooed me first— this bathroom was the spark that ignited my search for the best places to pee in Portland. I remember feeling both disorientated and wowed as I entered the bathroom. Jeffrey Kovel, of Skylab Architecture, designed this fabulous loo and has this to say about the design concept: "The Doug Fir bathrooms were designed with the psychedelic vision of dimly-lit dive bars with antique-mirrored walls, crossed with the more utilitarian function of the mirrored environments of the '70s." The bathroom's entire interior surface is enveloped with mirrors that have gold webbing throughout; the lights are the same golden yellow, and, as they skitter across the mirrored surfaces, they leave you feeling dizzyingly off balanced—in a someone-spiked-my-punch-and-I-liked-it kind of way.* And if you happen to walk in when the floor-to-ceiling stall doors are all closed, you can very easily be left thinking to yourself, "this is the craziest log cabin loo I've ever seen!"

* That dizzyingly off-balanced feeling can be multiplied to the 100th degree if you've already enjoyed a cocktail or two before walking into what looks like the internal realm of a disco ball.

830 E Burnside St.

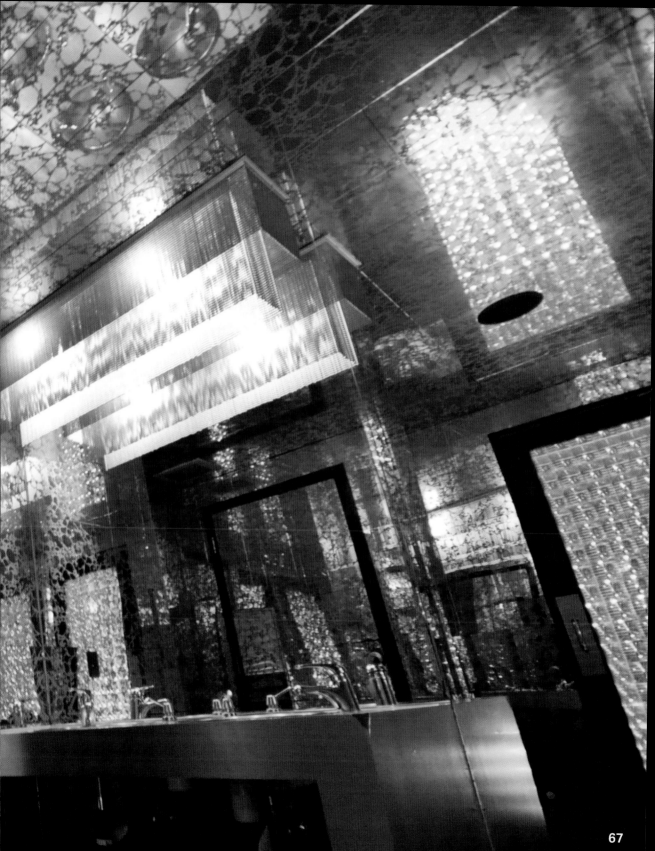

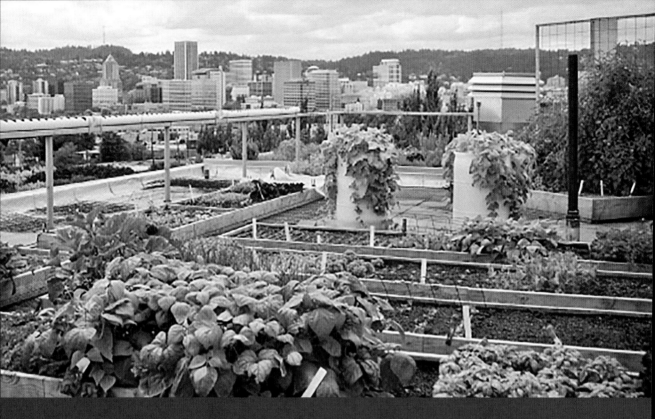

Noble Rot

IN THE WINE WORLD, THE TERM NOBLE ROT IS BEST DE-scribed as *Botrytis cinerea* (i.e., moldy grapes). While the name of this bar isn't the most appetizing, their food, ambiance and views leave a much more savory finish on your palate.

Noble Rot is a restaurant and wine bar that has been beautifully grafted to the top of an eco-friendly (LEED Platinum) building on East Burnside Street. Beyond the panoramic views, the rooftop also hosts a 3,000-square-foot organic garden that supplies most of the vegetables and herbs used in the restaurant's kitchen. Both the garden and the restaurant utilize an 800-year-old aquifer, which supplies pure and tasty water to the establishment.

Owner Kimberly Bernosky and husband-and-wife team Leather and Courtney Storrs are the richly spirited fertilizers who have kept this restaurant/wine bar producing exceptionally recognized vintages since 2002. Leather creates the restaurant's small, wine-driven seasonal plates, while Kim and Courtney mastermind the innovative flights of hard-to-find, delicious wines at reasonable prices.

Their restrooms have stayed loyal to the restaurant's eco-friendly vibe with valances made from recycled plastic and sunflower seed shells. Behind each loo is Noble Rot's own interpretation of the "happy little trees" landscape art, containing a water feature in each painting that flows into the toilet bowl. To further your enjoyment, the bathrooms are wired to the stereo system, so you can party while you potty, before rejoining your table out on the rooftop greenhouse.

1111 E Burnside St.

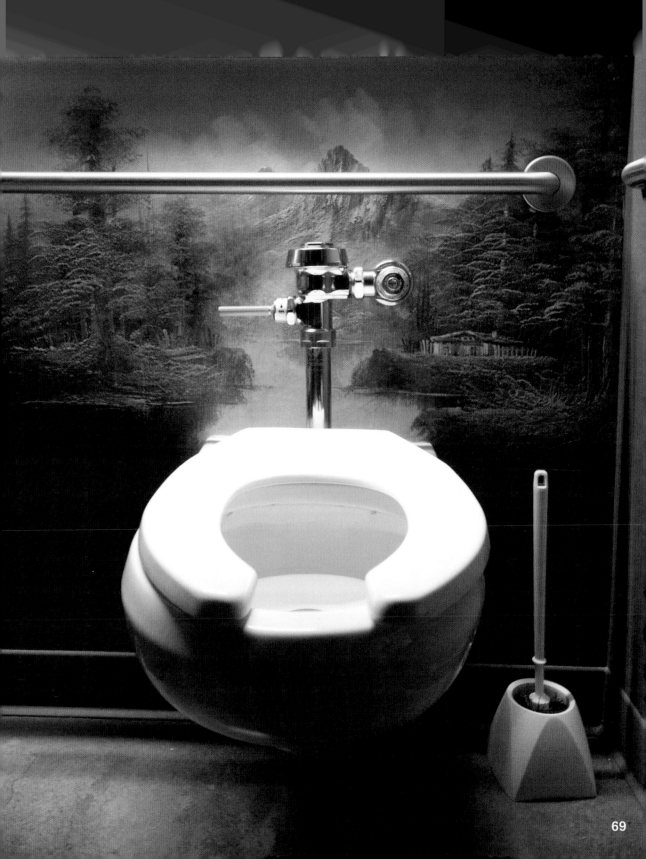

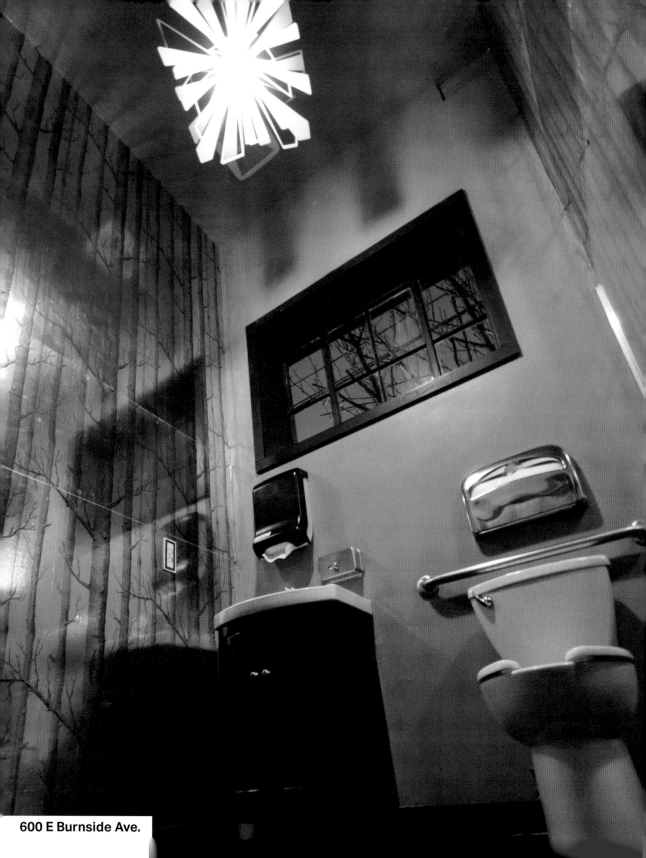

600 E Burnside Ave.

Rontoms

RONTOMS IS LOCATED ON THE BUSY CORNER OF EAST Burnside and 6th Avenue, with no definitive sign, no hours listed and an indistinguishable entrance; your clue to finding it is their obscure logo: a man with a propeller strapped to his back painted on the building's façade.

Once setting your sights on the propeller man, you'll enter to find a cavernous room with high ceilings and wood-hewed walls. The lounge is lit with an abundance of flickering candles, and intimate seating vignettes are scattered throughout the room. The space screams 1969 cocktail party with its low-slung chairs, couches and lustrous polyurethane surfaces that reflect and refract the candlelight. Floor lamps that bobble and sway, table lamps with shades as big as toddlers, and a color palette of mustard yellow, mossy green, burnt orange, and red add to the retro vibe. Centered in this space is a sunken living room of sorts, with couches and chairs lining the perimeter, complemented by a fireplace that anchors and enhances its living room quality. The food also mimics the retro vibe with plates such as deviled eggs, Swedish meatballs and fondue.

The owner, RonTom, worked as a designer before tackling the restaurant business. Tom's talent and solid vision created a gathering space that encourages its patrons to relax and linger. Weekly events consistently draw in crowds of friends for food, mingling, and lingering. A projection screen unfurls to host movie night, and local bands play front and center in the living room during free weekly Rontom Sundays. On Portland's sunnier days, the sizable patio out back is bustling with people. Large potted bamboo plants soften the hard lines and skyline of this urban oasis. Sail cloth canopies create artistic shade overhead, while a ping pong table adds entertainment and a little lively competition. A great selection of local spirits stocks the teak bar and the interior walls boast vibrant local art pieces.

This arty vibe courses its way into the restrooms. The tall walls of the ladies room are amplified with a silvery metallic forest of birch trees that shimmer and reflect the light from the chartreuse pendant light fixture and opposite walls of the same color. The men's room contains four large detailed sketches of faces, skillfully rendered by local artist Kris Hargis. These countenances create so much room for interpretation, it's a shame they are tucked away behind a closed door. Most men never even realize these sketches are on the wall in their restroom, so make sure to take a peek while you take a leek…

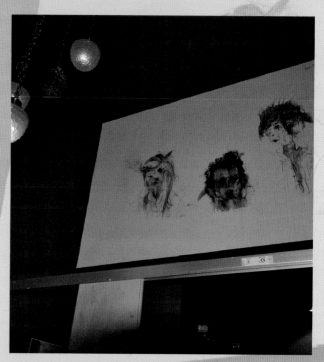

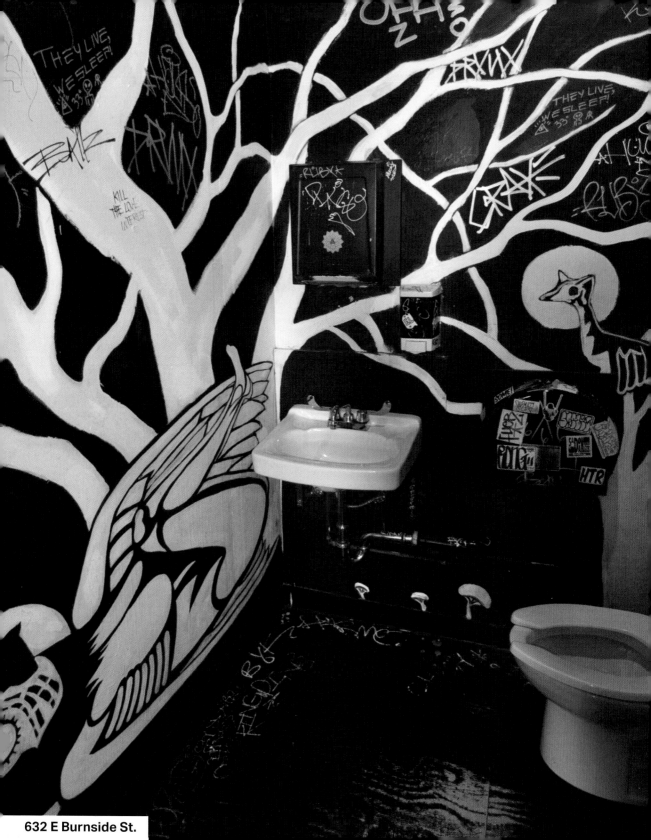

632 E Burnside St.

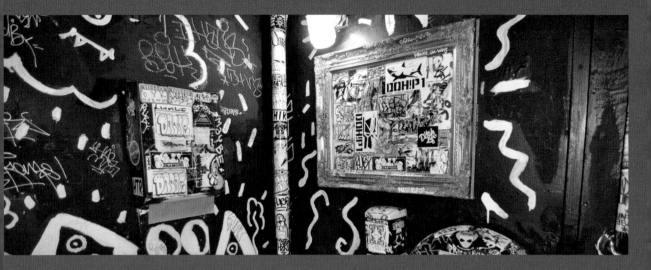

B-Side Tavern

TANYA FRANTZEN AND JOEL DENTON ARE TWO FRIENDS who had a vision, thirty thousand dollars, and an invaluable army of skilled friends—these three elements came together to form the B-Side Tavern. The business' beginning started with bare bones. When lights were needed above the bar area, they handed over a diminutive wad of cash to a friend, and artist, who specialized in welding. Wood boxes were crafted to frame old x-rays, resulting in a light fixture that captivates and illuminates.

Every nook and cranny of B-Side Tavern was crafted by the creative efforts of friends—and the bathrooms are no exception. Art camouflages every inch of the walls in the men's and women's restrooms. As the murals become "enhanced" by bar patrons, they inch closer to becoming a fresh canvas for the next local artist to showcase their talent and express their vision.

B-Side is a place to chill with your drink in hand, elbows on the table. The bar also offers you a great opportunity to put your money where your mouth is by participating in an arm wrestling tournament for charity! The second year in business, Denton was diagnosed with Multiple Sclerosis. This diagnosis led to the creation of an arm wrestling table and the birth of "Ladies of Arm Wrestling" Tournaments, which raise money for people living with MS.

Some more amusing tidbits about the B-Side Tavern…B-Side as in:

A) Burnside
B) Lesser known but cooler, like most B-Sides of vinyl records.
C) If Portland was a record, the east side would be the B-Side, and downtown the radio hit.

* Some other B-Sides that boasted A-side billing: "I Will Survive" by Gloria Gaynor was the B-Side of "Substitute;" "Maggie May" by Rod Stewart was the B-Side of "Reason to Believe;" and "Single Ladies (Put A Ring On It)" by Beyonce was the B-Side of "If I Were A Boy."

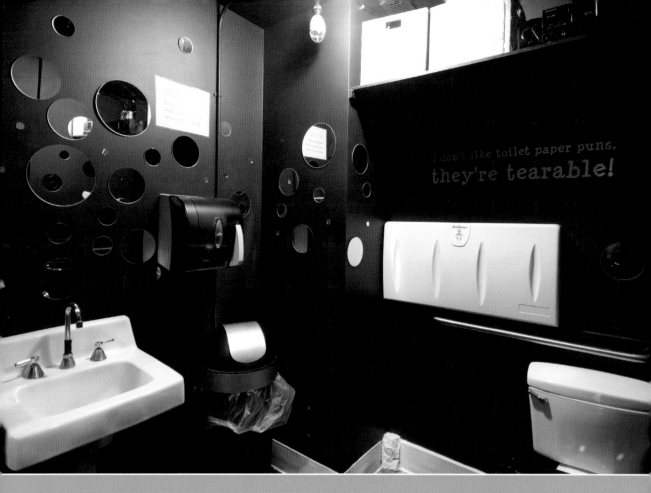

I don't like toilet paper puns, they're tearable!

Off The Waffle

BREAKFAST FOR DINNER ALWAYS ROUSES THE CROWD AT MY house. Then again, so does declaring that it's a no-pants day to my five-year-old! For the rest of us over the age of five, breakfast—especially waffles—always seems to make mouths water.

Walking up to the entrance of Off The Waffle in Southeast Portland, you're immediately struck by two things: the sweet aroma permeating the air and the marquee of the landmark Clinton Street Theater, located kitty-corner. The Clinton Street Theater is known for its weekly screenings of *Rocky Horror Picture Show*, a Portland tradition since 1978!

Off The Waffle is a family-owned business—dreamed up, launched and expanded by brothers Dave and Omer Orian. As kids, they traveled around the world and spent a portion of their childhood growing up in Belgium. One of Omer's first memories is from his time in Belgium, when he received a delicious Liège (pronounced LEE-EJ) waffle from his kindergarten teacher as a reward for a *full* day free of ruckus-making.

Dave and Omer have grown up since their days in Belgium and, theoretically, are now causing a lot less of a ruckus these days. Even so, Liège waffles have remained a constant reward for the brothers. In 2009, after more world traveling, Dave and Omer found themselves in San Francisco without a source

2601 SE Clinton St.

of income—although they were the proud owners of a used Honda Prelude. That Honda carried them up the coast to the Pacific Northwest, specifically to Eugene, Oregon. The brothers quickly fell in love with Eugene and its community. And it's often said, falling in love inspires some people to cook!

Dave and Omer started experimenting with their waffle recipe…shortly thereafter they were ready to share their sweet, crunchy, yet soft, Liège waffle with the good people of the Pacific Northwest. The waffles were a hit, and now the brothers have expanded Off The Waffle, with two locations in Eugene and one in Southeast Portland.

Liège waffles are sweeter than their more common cousin, the Belgian waffle. The key contributing ingredient of a Liège waffle? Chunks of pearl sugar that are folded into the dough, melting and caramelizing the outside of the waffle as it bakes on a hot cast-iron waffle press.

You know what else is sweet? Off The Waffle's bathroom. It's been disco-fied! The light switch is labeled "on," "off," and "disco"—in the disco setting, the lights turn from white to bright colors, the music starts to groove and the disco ball starts turning. This is the ultimate party potty!

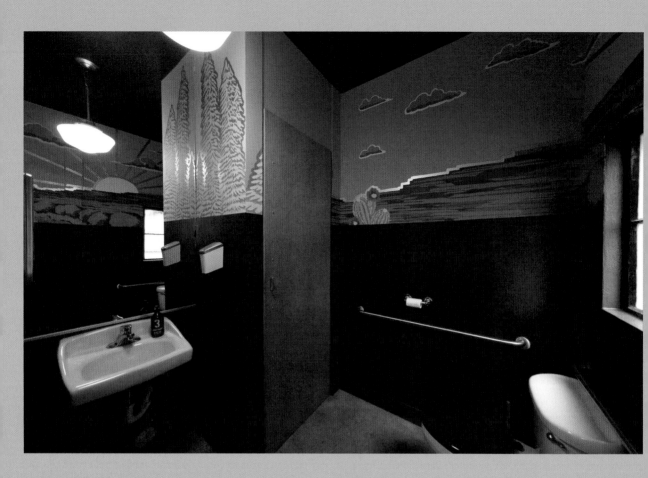

Rudy's Barbershop

IN THE EARLY '90S, ALEX CALDERWOOD, WADE WEIGEL and David Petersen had a wild hair of an idea. They wanted to open up a barbershop in the Capitol Hill neighborhood in Seattle Washington.The concept was simple: you wake up on a Tuesday and want to get your hair cut. Not only did Rudy's provide a great haircut, at a decent price, based on your schedule, it also provided a place where people started to gather, hang out and build a sense of community. Rudy's was an instant hit.

No one predicted the huge success Rudy's would turn out to be, but soon enough Rudy's was open 12 hours a day, seven days a week and always full! A second Rudy's was soon opened in Seattle. Today Rudy's Barbershop can be found in four cities: Seattle, Portland, Los Angeles and New York City, with a total of 16 barbershops.

"Everything we do starts and ends with community." Rudy's loves their staff, their clients and their various neighborhoods. Very active in community support, Rudy's is philanthropic as well as fashionable. The simple idea of a neighborhood barbershop has success-fully evolved into a crossgenerational community center that creates a positive source of energy by mixing art, music and good people together. The atmosphere is less

3015 SE Division St.

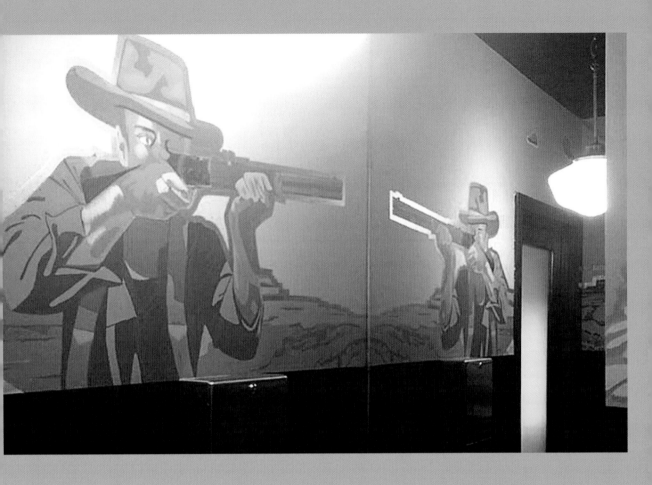

high maintenance than at other salons, and stylists are free to express themselves and encouraged to take time off when needed to embrace their creativity.

So who is Rudy? A group of kid graffiti artists created the first mural on the wall inside the barbershop on Capitol Hill, and while Alex, Wade and David were discussing names for the shop, they asked the kids for their suggestions. One kid said matterof-factly, "Rudy's." When asked why, he and his friends explained that Rudy was from Fat Albert and was a carefree dude, so the kids coined the phrase "Let's go have a Rudy kind of day." After telling that story, one

of the kids turned around and tagged their own mural with Rudy scrolled across the center. So Alex, Wade and David went with it and painted Rudy's on the window, and that's how Rudy's Barbershop was born.

Each location varies with its decor, but the vibe is always the same—retro hip, relaxed with a worn in industrial interior and a colorful personality. The staff and stylists are artistic, and most everyone finds the price point more than fair. The bathroom at the SE Division Street Rudy's has a rich, jewel toned Southwest mural that wraps around this angular shaped bathroom, transforming this john to a John Wayne–esque experience.

Bollywood Theater PDX

Hey, REMEMBER THAT TRIP TO INDIA, WALKING THROUGH the crowded streets, smelling the fragrant spices, buying food from a vendor and then tasting it and realizing those flavors will forever be on your top 10 list? Remember seeing the parade of rich jewel-toned colors on the people, buildings and packaging as you walked through the crowded streets? Remember the vibrancy of life and curiosity reflected on the locals' faces when you interacted…

No? Well, no worries. Troy MacLarty, chef/owner of Bollywood Theater PDX, will give you that experience without ever having to leave Portland! Dining at Bollywood Theater immerses all your senses in Indian culture. When MacLarty set out to open Bollywood Theater, his dream was to make you feel "as if you've gone someplace." After setting foot inside this restaurant, I think you'd agree that MacLarty did a bang-up job turning his vision into a reality.

The decor inside Bollywood Theater explodes with mementos of India. Meals are served up on steel plates while matching steel cups sit by the water station. Colorful collectibles reach every corner of the interior. A movie screen shows footage from popular Bollywood action flicks. Knick-knacks find homes along the nooks and crannies of the walls, and hanging lanterns, movie posters, weathered signs, framed pictures, banquets with colorful pillows and mismatched chairs all fill up the space to create a truly cinematic setting.

The colors, sounds and imagery don't stop in the dining room. Bollywood Theater has two locations, and each restaurant has two unisex bathrooms, each uniquely decorated. The bathrooms are colorful, whimsical and artistic. Wallpaper created from photos taken while MacLarty traveled in Mumbai line the walls. Images of street vendors in the marketplace, public transportation buses, even audio and video footage from his travels are used inside the bathrooms. The vibrancy, creativity and audiovisual effects in the bathrooms are an extension of what MacLarty envisioned with his goal of making you feel as if you've "gone someplace."*

The sights, the smells and the sounds of Bollywood Theater will fill you up with an experience that costs a lot less than a plane ticket but can be as tasty and memorable as if you did take that journey.

*Pun not intended but fully realized.

3010 SE Division St.

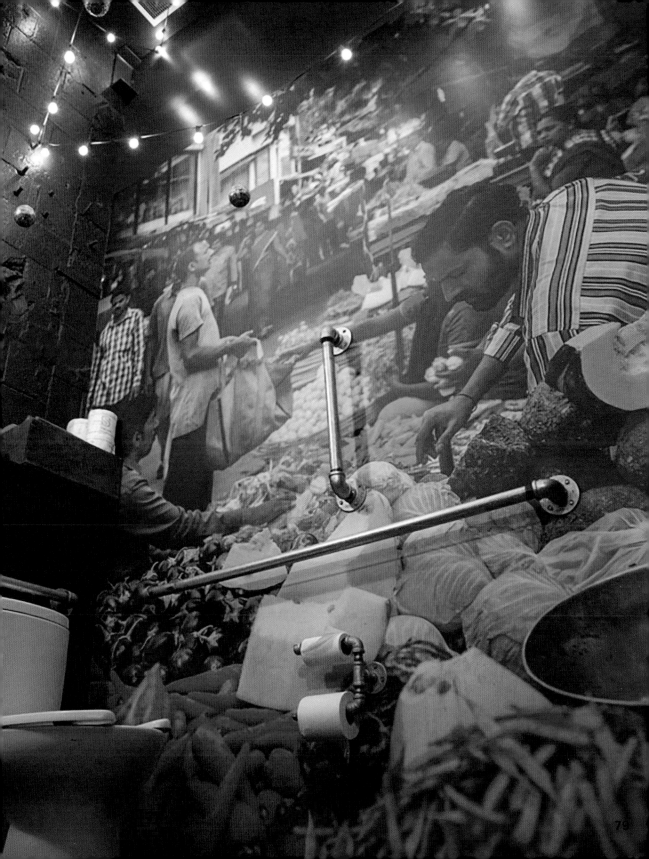

Rimsky Korsakoffee

CALLED "RIMSKY'S" BY REGULARS, THIS COFFEE AND DESsert shop is housed in an old Victorian house in Southeast Portland. Its decadent desserts, cryptic décor, and haunted history have kept customers coming to this Portland landmark for 25 years. Its inconspicuous location usually leaves most inexperienced patrons circling the block a couple times before they find it. Don't be discouraged by its limited hours, lack of advertising, dark on-street parking: once you find Rimsky's, you'll be glad you did.

Rimsky's proprietress, Goody Cable*, considers herself an "assimilator of the mundane," weaving and collecting stories that make their way into this peculiar place. Each dining table is named after a deceased composer and topped with a moveable glass top so patrons can add their own mementos, which keeps the dining room's décor constantly evolving, much like Rimsky's menu. Curiously odd items hang from the ceiling—see if you can determine their common denominator. Live classical music is played almost nightly on the living room's baby grand piano.

Cable professes the house is haunted by its former owners: a couple, both writers, who witnessed the Russian revolution. Correspondingly, it has been purported that several tables at the café exhibit odd behavior, such as levitating and turning ever so stealthily. Patrons have reported that, after getting lost in conversation, they'll notice that their dessert has mysteriously made its way to the place setting in front of their companion (whether this is on the part of supernatural forces or hungry dates, we cannot

confirm). The frosting on Rimsky's not-so-proverbial cake of odd ingredients is what awaits you on the second floor in the Erik Satie inspired bathroom. If you go with friends who have not seen these pictures, don't give away the surprise that awaits them through the door—just follow them up and listen to their startled squeal as they flip the light switch on.

With homemade desserts served by sassy servers, and a bathroom that will fright and delight, Rimsky's is a one-of-a-kind Portland spot worth the trip.

* Goody Cable also co-owns the literary-themed (and equally eccentric) Sylvia Beach Hotel in Newport, OR.

707 SE 12th Ave.

Ned Ludd

JASON FRENCH, THE OWNER OF NED LUDD, WORKS UNDER the umbrella of ingenuity and spontaneity. He created a rustically chic dining room, which channels a modern day workshop replete with weathered wood furnishings, exposed beams, vintage light fixtures, and glassware. A wood-fire oven remained from a failed pizza joint that was previously housed here.

Equipped with the wood-fired oven, a two-burner hot plate, a small alto sham, and a steam table, the "kitchen" clearly operates on wood, not gas, churning out memorable meals that keep throngs of faithful and curious diners flooding the restaurant nightly.

Seasonality is key here with ingredients changing weekly. A garden planted out back supplements the ingredients sourced from local markets and farms. Rainwater is collected to help water the garden, bins of fruitwood (fuel for the oven) outline the seating area in front of the restaurant, and hints at the farm-driven rustic cuisine that awaits you inside.

As expressed in the foreword to this book, French believes bathrooms are an extension of one's dining experience beyond the food, the service and your dining companions. The bathrooms at Ned Ludd are a vestige of an era gone-by, reflective of French's fondness for antiquity and beauty. Turquoise and yellow canvas the walls and charming one-off items collectively displayed within the bathroom tell a story.

Both washrooms embody the pioneering movement of a generation that dealt with hard times in exchange for the plethora of possibilities awaiting them. This is seen in the faces of the vintage photos (including a photograph of French's dad), seasoned tools, doses of humor (such as the rap poster hung in a gold Goodwill frame), and an abundance of organic elements that fill every corner of these one-room odysseys.

This pioneering spirit is reflective of French himself. His journey has taken him thousands of miles while accruing hundreds of experiences that have culminated in incredible joy and success as a restaurateur.

3925 NE Martin Luther King Junior Blvd.

Binks

BINKS' OWNERS, JUSTIN AND BIANCA YOUNGERS, CON-
sider their bar an extension of their living room,
and accordingly, they regard their patrons as their
extended family. Binks has been an Alberta Street
fixture for over a decade and has the reputation for
the friendliest bartenders in town—even on their most
bustling nights. Their cozy and intimate fireplace
nook and tequila toddies invite chilled and slightly
soggy Pacific Northwesterners indoors during the
winter months. And when the sunshine returns and

dries up the puddles, garage doors open up wide to
allow the welcomed rays in. During these summer
months, Binks' tables spill out onto Alberta, creat-
ing inviting sidewalk seating—ideal for art-district
people watching. Fresh-squeezed juice and house-
infused vodkas combine to create refreshing and
inventive cocktails.

What does "Binks" mean? The true story is sweet
and simple: it was owner Bianca's childhood nick-
name. The alternate story Bianca likes to spin is that

2715 NE Alberta St.

Binks is an ancient Chinese remedy for a hangover. The Youngers' wit goes beyond cleverly woven tales of herbs and ancient Chinese secrets.

The bathroom just beyond the colorfully-painted archway is home to the infamous "lift-the-skirt girl." What appears to be a plain wooden plaque, painted with a simple and unassuming rendering of a girl with a wooden skirt, is not as simple and unassuming as it seem…If, in the privacy of the bathroom, you should find yourself curiously intrigued by the thought, "just what is hiding under that skirt?" go ahead and lift it! You'll soon find…absolutely nothing! Hmmm…although you see nothing, the patrons sitting at the bar adjacent to the john see a bright yellow light turn on, signaling to everyone that you have a slightly naughty curiosity when you think no one is looking. Depending on the crowd who has taken up residence at the bar during your inquisitive exploration, don't be surprised if you walk out to a round of rollicking banter, incited by your quest to explore.

2132 NE Alberta St.

Bishops Barbershop

IF YOU BELONG TO GENERATION X, Y OR Z AND/OR LIKE listening to Run DMC while you toss back a cold one and allow a slick stylist to cut your locks, then this is the place for you. Owner Leo Rivera had a self-imposed goal to create a business of his own before he reached the age of 30. The outcome was this edgy "Poor man's social club"—more commonly referred to as Bishops Barbershop.

Incidentally Rivera himself is bald—so what does Bishops Barbershop mean to an entrepreneur who is bald? It's the culmination of a self-imposed aspiration and homage to his much-loved half Rottweiler, half St. Bernard who was affectionately called Bishop. Rivera's vision was to take this universal, albeit uneventful necessity of getting a haircut and turn it into an experience by submerging it within a bar-like setting.

Bishops Barbershop opened its doors to Portlanders in 2001. Since then, it has provided Portlanders with accessible style at half the cost of regular salons, while creating a cool buzz culture of its own—it is, indeed, Portland's original Rock 'N Roll Barbershop.

Here the decor is edgier, the music louder, and the conversation less conservative than at many other salons. Although each location has a slightly different vibe, you can expect to see a staff of tattooed stylists, an occasional DJ spinning tunes, and walls canvassed with magazine clippings. The walls may look like the product of a rebellious teenager who has decoupaged his room with pictures and phrases to agitate his parents, but most of these collaged walls do have a theme.

Every john within the Bishops Rock 'N Roll realm has some funky, eccentric thread or message that has sprouted within that personal space. Some bathrooms show a devotion to kitties, others promote fashion icons, and if you're lucky (in a weird sort-of-way) you might get the pleasure of peeing with the steely eyes of Jeff Goldblum and Christopher Walken peering at you.

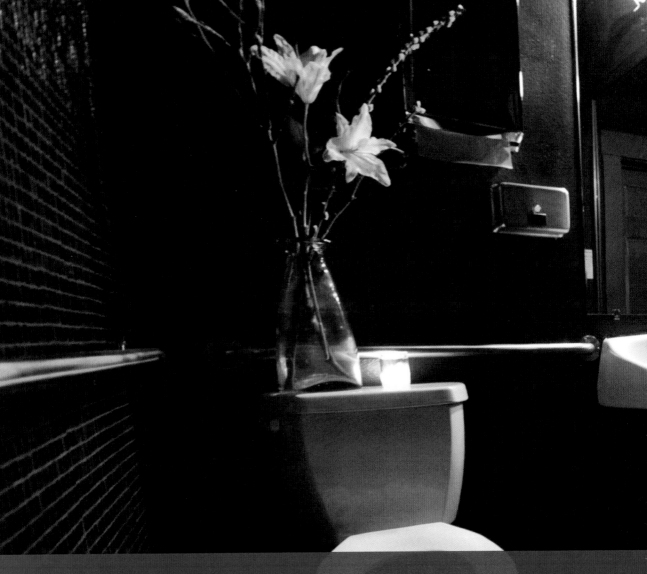

Zilla Sakè

NORTHEAST PORTLAND'S ZILLA SAKÉ WAS BORNE OUT OF proprietress Al'lowe's vision of an Ewok village teahouse tree house. Before opening this sushi house, Al'lowe was an artist and high school teacher with a background in anthropology and magic. She started her Northeast Portland sushi bar and sake house with the intention of creating an inspirational space that embodied the art and culture of its surrounding neighborhood.

Al'lowe's creative vision came to life on the walls of Zilla Saké. Its interior—everything from its hand-carved booth partitions to the lighting fixtures—is a collaborative endeavor by members of the Portland art community, lending the restaurant an ambiance that feels distinctive and organic.

Zilla Saké serves 80 premium sakes to explore by the glass, tokkuri or full bottle. The beautifully

1806 NE Alberta St.

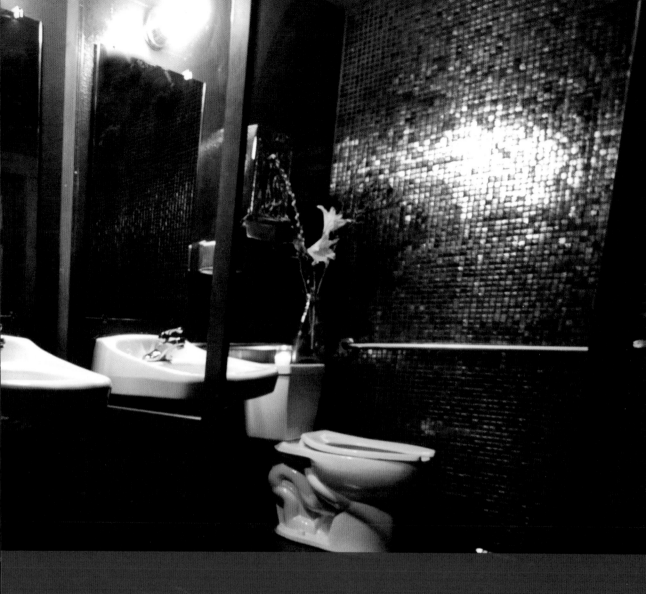

stunning and highly skilled sushi chef, Kate Sollitt, is lovingly referred to as the "Sushi Nazi," and she appropriately turns out strictly delicious sushi. This sushi bar and sake house has settled into being one of the most interesting and economical spots in Portland to drink and develop your sake palette, while enjoying meticulously chosen and prepared sashimi, nigiri and maki sushi.

Even though Zilla Saké's all-black bathroom is located on Portland's Alberta Street and not on the Forest Moon of Endor, it twinkles with an iridescent incandescence, much like the glowing lights hovering in the Ewok village. The floor and wall are cloaked in iridescent black tiles and reflected in a fully mirrored wall, turning this bathroom into an exotic chamber.

The Red Room

In H.G. Wells' gothic short story, "The Red Room," the protagonist reveals the room is not haunted except by fear itself. In *Fifty Shades of Grey's* red room, Anastasia is confronted by the fear, excitement and pain that Christian plans to unleash on her…Well, neither relate remotely to this Red Room.

The Red Room, set back off of Northeast 82nd Avenue, is a neighborhood dive bar that hosts punk, rock and metal bands. The facade of the building is drenched in an appropriately red hue. Enter this exuberant music box to a jukebox constantly looping through songs, Guitar Hero, pool tables, darts, and friendly bartenders. This intimate space is aglow in crimson colors, and the low ceiling hugs the sound in tight when the bands take to the stage.

Just beyond the musicians rocking it out on stage is a gallery of other well-known musical icons who have "mugged" for the camera—except these snapshots are actually mug shots.

The accent color of red complements the music typically played here: bold, shocking, angry, and loud. The punk vibe of the music correlates with the punk characters seen in this dive's pissers. These characters colorfully and graphically radiate their peevish attitudes via their bad-boy mannerisms. Even if they don't offend you, you'll be sure to leave this john seeing red.

2530 NE 82nd Ave.

The Secret Society

THE SECRET SOCIETY IS NOT REALLY A SECRET — AND NEI-
ther is their acclaimed Ladies Lounge. This gem is
home to a cocktail lounge, recording studio, and ball-
room, but the Ladies Lounge stands apart as perhaps
the most beloved powder room in Portland. The owner,
Matt Johnson, initially developed this space as a re-
cording studio and music resource center. The building
had housed fraternal organizations over the past 100
years and the halls echoed their rich history. After the
opening of a small successful restaurant below this
space — with diners milling about on the sidewalks
waiting for a table and a bustling music venue adjacent
to his space — Johnson knew he could showcase the
rich history and charm of this 1907 building by offer-
ing a swanky lounge environment that could cater to
diners and show-goers alike.

From day one of this design conception, Johnson
knew that he wanted the establishment's menu, style,
and function to reflect the history of the building,
and the Ladies Lounge is indeed a reflection of its
Victorian heritage. During the Masonic era, this room
once functioned as the building's anteroom, where
visitors — primarily the female companions of lodge
members — waited to be accepted into the lodge. It's
easy to imagine the room brimming with women chat-
ting and exchanging gossip as they waited for their
men to finish up lodge business.

Today the warm, soft pink walls, dark mahogany
woodwork, oversized red couches, votive candles, and
a vintage chandelier in the room harkens back to the
jazz club era, when women would commonly ask their
dates for money to tip the powder room attendant. On
any given weekend you'll still find women gathering
in this Ladies Lounge, primping in front of the gilded
mirrors, or lounging on the cushy red couches while
sipping a superbly crafted cocktail. When you visit
The Secret Society Ladies Lounge, see if you can't
feel a century's worth of past girlfriends right there in
the room with you, ready to share a little juicy gossip
or let a sister know when she needs to fix her hair.

116 NE Russell St.

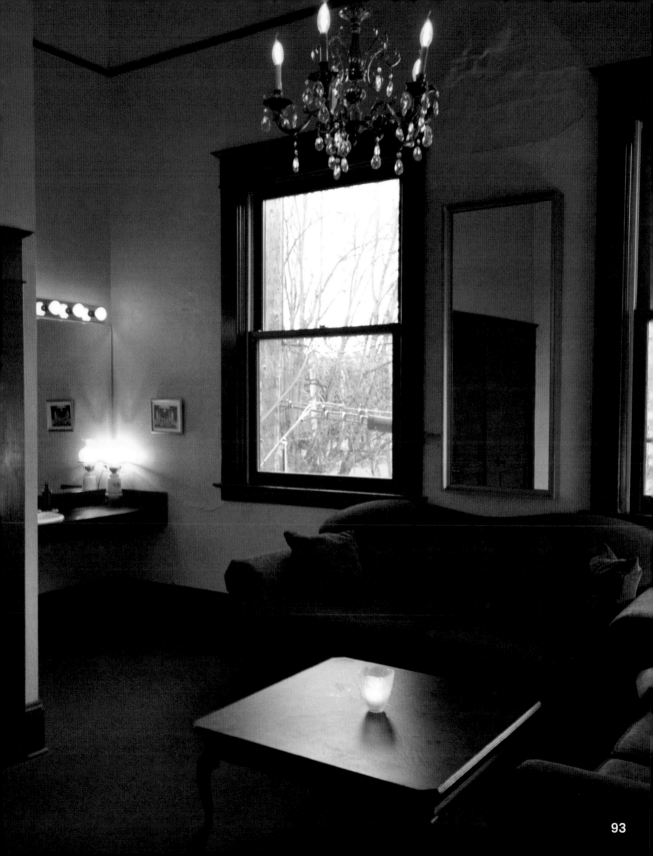

Spirit of 77

SPIRIT OF 77 IS A PORTLAND-CENTRIC BAR FOR THE ULTIMATE sports enthusiast. The name commemorates the city's singular glory moment in sports history; in 1977 the Blazers won their only League Championship behind the efforts of their star center Bill Walton.* Inside, Spirit of 77 boasts an illuminated, vibrant orange "Spirit of 77" sign that sets the tone for this exuberant place. The theme continues outside the building with an oversized 36-foot sign that reads: "This is RIP CITY," the catch-phrase coined by the Blazer's beloved former play-by-play announcer, Bill Schonely.

This 3,000 square foot sports fan haven boasts four 55-inch flat panel televisions, plus a 9x16 foot projection screen dedicated to showing the biggest games of the day! The backwall of the 36-foot long bar is decorated with a repurposed basketball court originally used at Hillsboro High School. Twenty-eight bar stools plus another nine tables, each 10 feet long, fill the floor, but allow enough space for fidgety fans to sit, stand or pace as the fortunes of their favorite teams shift with the dwindling clocks.

Fan-friendly design elements place this sports bar in the upper echelon of game-day hangouts. Inside this A.E. Doyle-designed brick building is a Portland-centric bicycle parking area with a coffee and espresso dispensary next to it. A locally built "Buzzer-Beater" basketball shooting game is in place to accommodate the competitive patrons or nervous nellies in the crowd. Soccer fans take up house here as well. Pregame and postgame foosball matches ensue on the Rolls Royce of foosball tables, with a French made Renee Pierre Zince model that retails close to 2K!

When you need to take a break from rabble-rousing and beer guzzling, wander past the photobooth and you'll find another room where there's a competitive, albeit humorous, edge. The men's room takes a laughable approach to the concept "size does matter." Spanning across the distance above the wall of urinals is a mural depicting a wide array of sports balls and their respective size. So for those of you guys who've ever wondered how you "measure up"—well now you have a pretty good idea visually just where you rank!

* See how Bill Walton is connected to Old Town Pizza Co. (p. 20).

500 NE MLK Jr. Blvd.

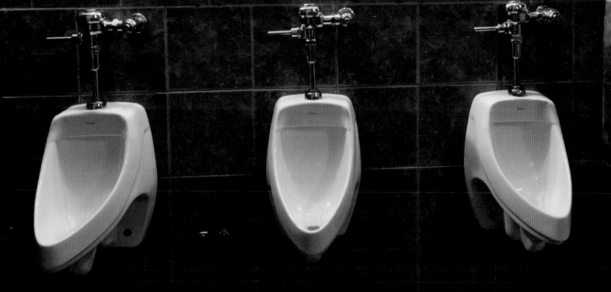

Random Order Coffeehouse & Bakery

AN OSTRICH, AN ARRAY OF SWEET AND SAVORY PIES, COF-fee, cocktails, a camouflage floor and an old bakery building from the early 1900s—all random elements that have been successfully brought together to create Random Order Coffeehouse on NE Alberta Street.

"Random order is the way of the world. Life presents you random elements, and you unify them into a cohesive whole." This is the philosophy that resonated with Tracy Olson when she decided to take a stab at opening a pie shop in Northeast Portland.

Once an avid amateur photographer and mixed-media artist, Olson also enjoyed attending shows at punk rock venues and had fond childhood memories of pie. Hmm, well, why not unify these elements into a vibrant neighborhood café that offers extraordinary handmade pies?

Random Order Coffeehouse opened in 2004, and the outcome was apparent: everyone loved the pies!

People were eating them up like hotcakes, except they were pies, not hotcakes.*

Whether it's their sweet and savory pies, pot pies, quiche, hand pies or pastries, Random Order takes great pride in crafting these delicacies from scratch every day. Butter pastry crusts are handmade and filled with the freshest seasonal ingredients from local growers. Available whole or by the slice every day starting at 6:30 a.m.

A focus on the simpler pleasures in life—like pie, laughter, community, comfort, and a funky punky bathroom—can all be found inside Random Order Coffeehouse & Bakery. This bathroom definitely fits within the scope of funky with its hand-painted camouflage floor, scantly clad white walls and a patch of PVC artificial wheatgrass plugged onto the wall behind the mirror. A randomly ordered bathroom that makes you smile inside this sunny corner-side bakery.

*Try taking a stack of hotcakes to Thanksgiving dinner—I doubt that will get you on the "I'm thankful for…" list. Stick with pie, especially an awesome pie from Random Order—it gets you on the list every time!

1800 NE Alberta St.

555 NE Couch St.

Ristretto Roasters

DIN JOHNSON IS THE OWNER AND ONE OF THE ROASTERS at Ristretto Roasters. Ristretto specializes in small batches of medium roast, handcrafted coffees. Their coffees are researched and sourced directly from farmers who care as much about producing a quality coffee bean as they do about offering a well-balanced cup of coffee. Many of the farms behind the beans are small family businesses, and Ristretto strives to offer Direct Trade certifications as much as possible.

Ristretto is an Italian word that means "limited" or "restricted." In the world of coffee, ristretto is also a short shot of espresso made with the normal amount of ground coffee but extracted with half the amount of water.

All this coffee slanguage is great for Tuesday night trivia, but don't let it skew your perception of Ristretto Roasters. "Limited and restricted" at Ristretto only applies to the number of people you'll see wearing jeggings at this coffee café.

Ristretto's roster of single-origin coffees changes with the seasons and in conjunction with what the farmers are growing. If consistency is your cup of joe, then you're in luck—Ristretto has signature blends available on a daily basis. Beaumont Blend, for example, is a tribute to their roots and named after the neighborhood that housed the first Ristretto Roasters.

The roasting house's vintage UG-22 Probat roaster is at work roasting beans on a daily basis. Interested in learning more about the tasting notes of coffees? Cuppings are offered at each of the Ristretto locations every week. Curious to see the roaster? All you have to do is ask. At Ristretto, they love their curious coffee fans and they love what they do, so if you ask for a tour, they'll gladly show you around.

Another example of Ristretto's unique modus operandi is the cool fact that this coffee café serves beer and wine—plus, in their Northeast location, there's a projector that shows all the Timbers and Blazers games! So you can clearly see that Ristretto is anything but limited and restricted.

They don't fall short on having a noticeable bathroom either. Bamboo Revolution is the designer of this coffee café's bamboo-clad water closet.*

*See pg. 120 for more information about Bamboo Revolution.

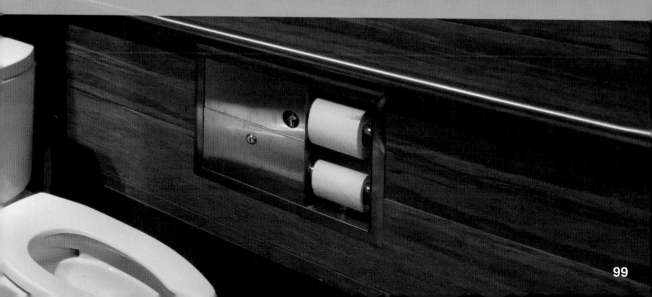

828 SE 34th Ave.

The Side Street Tavern

TAKING THE SIDE STREET OFTEN LEADS YOU TO PLACES WITH authenticity and a style that veers away from the typical. When people discover these gems, they continue to go back because of the gratification they gained by following the road less traveled.

The Side Street Tavern is a vibrant neighborhood bar that prides itself on fresh-squeezed cocktails, local beer, and being nice to its customers. The facilities at The Side Street reflect management's affection for their costumers as well as their confidence that their patrons are witty and entertaining. Chalkboard walls are not new to bathrooms and one can easily deduce that creating these kinds of walls cuts down on the typical penchant some bar patrons have for graffiti. A shiny silver bucket of colored chalk sits in the corner of this colorful create-your-own-wallpaper bathroom, anxiously awaiting another fondling by the next exuberant artist. With almost every toilet flush, art magically appears on the walls in the form of masterpieces that entertain rather than offend. These walls tell a story through skillful images created from affinities with pop culture, whimsical sayings written in foreign languages, and playful drawings of objects that produce smiles (and lingering bathroom visits).

Advice for those who plan to spend some quality time in this water closet: if you are going to make people wait in line while you're leaving your mark on the walls, it better be good! And consider this a public service announcement: the bucket is indeed filled with colored chalk, not candies, as the poor guy who exited the bathroom with multi-colored-chalk-stained-teeth quickly learned.

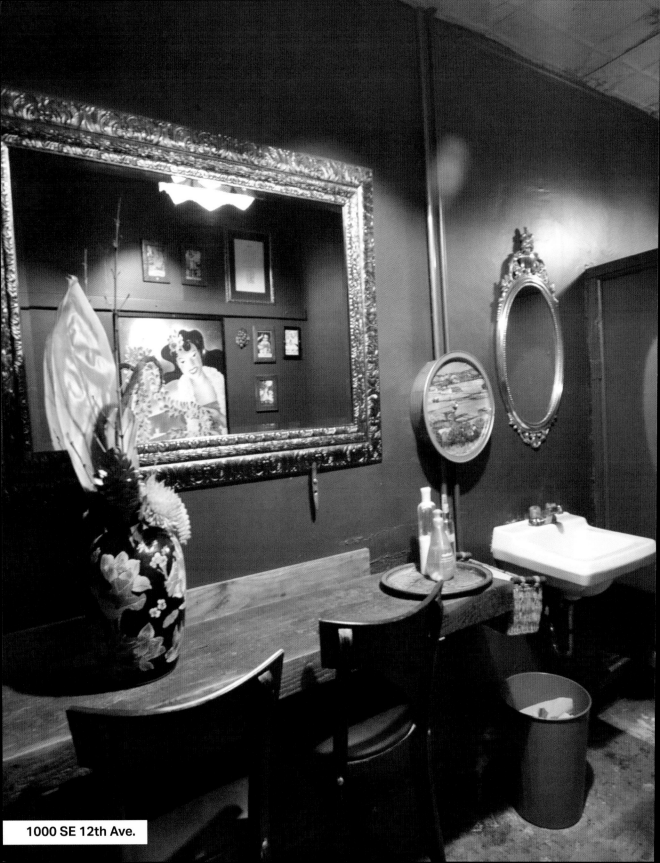

1000 SE 12th Ave.

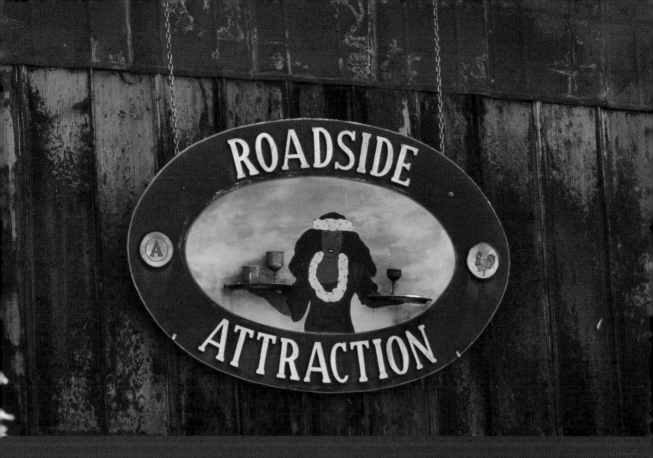

Roadside Attraction

ROADSIDE ATTRACTION IS A LOCAL BAR THAT HAS SUC-
ceeded in living up to its name. As you drive by, you
can't help but gawk at all the odds and ends that over-
flow onto the sidewalk and bait you to explore beyond
its wooden fence. If your curiosity's been piqued, and
you manage to find parking, your inner adventurer
will be pleased. Not only will you find the large pa-
tio with a fire pit, flowering vines, and exotic flower
arrangements meticulously well kept, most will find
the massive collection of mismatched attractions curi-
ously captivating.

After hosting many a party in their living room,
owners Alf Evers and Peggy Barr decided to turn their
house into a uniquely homey bar in Southeast Portland.
Evers jubilantly explained that he had "the bar and

booze installed way before they ever opened their
doors as a business." Clearly the essence of Roadside
Attraction was embedded in this dwelling's foundation
long before its doors were open to the public.

The bathrooms here are an extension of the bar's
overall experience. The ladies room offers a taste of
the islands with a Hawaiian motif that errs on the
classic vintage side rather than Pacific Island kitsch.
Hula girls with inviting smiles, out-stretched arms, and
luscious looking leis are captured in gilded frames as
you enter the spacious rose-colored washroom. A fresh
and exotic flower arrangement and sweet-smelling
powder room products make you feel unexpectedly
pampered—this is not your average neighborhood
bar bathroom.

Dig a Pony

WHETHER YOU DIG A PONY, DIG BARTENDERS THAT WEAR fedoras, or dig a really cool vibe, you'll dig the atmosphere at this Southeast Portland bar. Dig a Pony (DAP) is a place for trend-setters, dapper dudes, smart-looking lasses, and old souls. It was thoughtfully crafted by a young group of entrepreneurs—Jacob Carey, Aaron Hall, and Page Finlay.

Their goal was to create a warm and welcoming bar for the hip and sophisticated, minus the pretentiousness and high price tag that usually accompanies such an establishment. With the intention of being a "rad-pad" with sophistication, DAP's aesthetics can be described as a "turn-of-the-century, Northwest kind of affair." A beautiful horseshoe bar anchors the space. Vintage lighting illuminates the plethora of bottles that sit on the bar's wood hewn floating shelves, creating a fanciful focal point to the room.

In 1917 the building was home to Potter's Drug Company. The recent renovation uncovered beautiful old beams and the original tile floor that are now left exposed, adding character and warmth to this space. During the day this room fills with natural light from the two walls of windows. Punctuating the cozy library vibe are bound books tucked into shelves, beadboard backing the walls, a 110 year old piano, and custom stained glass work.

By nightfall, the room transforms from a quiet "library" to a multifarious room of 30-Somethings with contemporary cocktails in hand, mingling over the sounds of hip DJs spinning anything but top 40 music, seven nights a week. DAP may have a library feel, but it's anything but stuffy, and the bathrooms reflect its ability to balance the classic with the eccentric.

Enter the privy, where a soothing blue-gray colors the space, weathered-wood frames the antiqued mirrors, and a bold, custom painted Yak graces the wall—keeping a steady watch over the bathroom happenings. DAP embodies the lyrics of the Beatles song for which it was named: stop in and "you can celebrate anything you want. Yes, you can celebrate anything you want."

Header photo credit, Aaron Cohen.

736 SE Grand Ave.

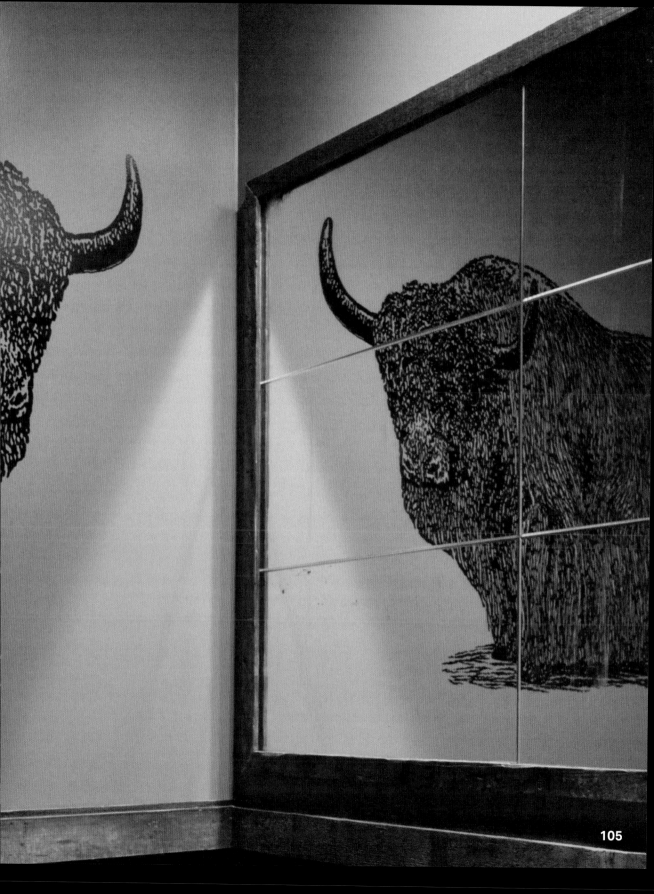

The Observatory

AN ANCHOR OF SOUTHEAST STARK STREET, IN THE Montavilla neighborhood, The Observatory is the creation of two young couples who had stars in their eyes and restaurant experience in their back pockets. Looking beyond the bar's twinkling plethora of local and homemade spirits, you'll find salvaged church pews converted into banquet seating, and walls embellished with pictures of far-off galaxies and nebulae. Raining down from the ceiling, wires crisscross as if connecting the points of a constellation, each end illuminating a handcrafted light bulb that, when intertwined, shines like a cluster of distant yellow stars. Stargazing can spark your imagination and fuel your thirst for adventure. Quench that thirst with any one of The Observatory's hand-crafted, creative cocktails, such as the "Tom Kah," made with

8115 SE Stark St.

Thai bird chili-infused vodka, lemongrass cilantro, simple syrup, coconut cream, and fresh lime, or "The Remedy," made with house-made pineapple honey vinegar and champagne, served on the rocks.

Keep your sights high while letting the signs—restroom signs, that is—guide your way to the stellar water closets. At the end of the hall, you'll spy two restrooms that boast the same design, but with different color schemes. Flip the light switch, turn your gaze upwards, and behold a star cloud encircling the light fixture overhead. Colorful Christmas ornaments of varying sizes have been inventively arranged and secured around the light fixture, creating a "star cluster" that casts a soft halo of light over the restroom.

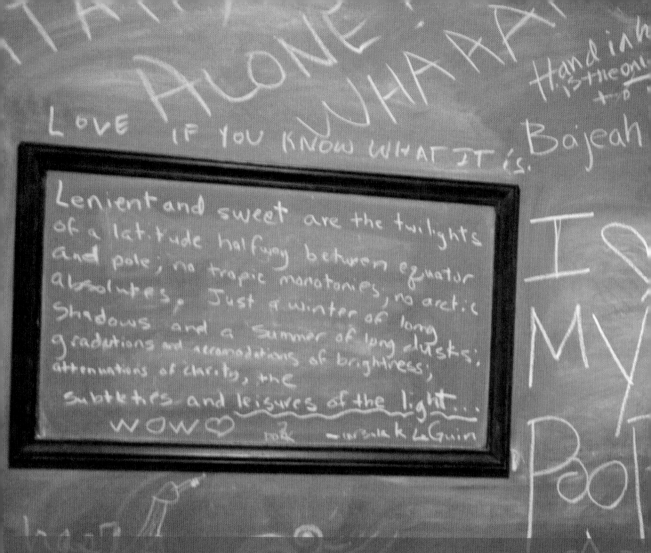

Over and Out

WHILE THE LOCALS WERE SIPPING SUBLIME COCKTAILS AT The Observatory, its owners expanded the borders of their galaxy and breathed life into a vacant space behind the restaurant, naming this adjacent bar "Over and Out." Slightly tricky to find, the easiest route would be to enter The Observatory, walk down the hall past the stellar bathrooms (see p. 106), through the door, and voila! You have now completed your journey, having travelled over to a new establishment, and out of The Observatory.

8115 SE Stark St.

Over and Out is appropriately deemed the "sporty little sister" of The Observatory, with five pinball machines, two pool tables, eight beers on tap, and the same delectable bites and inventive cocktails as its ever-so-popular big sister. Siblings often emulate one another and Over and Out is no exception. With shared parents, the expectations for quality, service and atmosphere have been held to the same standards and the john in this spry little sister is no exception.

The chalkboard walls conjure up a cheeky type of humor and hipster inventiveness. Many restrooms in Portland have utilized chalkboard paint on their walls but this loo went a step further by hanging frames, as purposefully offering Portland's clandestine artists and bathroom authors a gallery for their art and water closet words of wisdom. The walls are washed down when they reach their capacity, so your masterpiece could live on for minutes, hours, or maybe even a few days.

719 SE Morrison St.

Morrison Hotel

IF YOU'RE A DOORS FAN, YOU'LL BE SMITTEN WITH THE spot-on Doors album cover decal that adorns the Morrison Hotel Bar's front window. Inside, '60s rock memorabilia carry forward the nostalgic vibe. The bar boasts a stellar selection of over 100 different bottled beers and an array of pinball games. In addition, the space has flat-screen TVs that always draw a group of zealot sports fans who belly up to the bar to share in the triumphs or tragic losses of their teams.

There certainly is enough to keep you distracted from your date—which is clearly never your intention—but when you combine men with balls and beer, this seems to happen unintentionally. Your guilt over said date-neglect (in addition to past juvenile misbehaviors) takes over as you walk into the men's bathroom. Plastered on the back wall of this john is a request and a warning from Chris Joseph, the owner of MOHO, declaring in lipstick-red words to stop vandalizing the walls.

Joseph also reminds you that "the quicker you are out of here, the less time I have with your girlfriend"—spoken like a man who has reaped the benefits of bar ownership in more ways than one. So, order your favorite beer, play some pool, admire the rock memorabilia, but try not to imitate the bar's namesake*… and I'd think twice about introducing your date to the guy behind the bar.

* We can all agree that Jim Morrison was an icon whose music is rightfully worshiped, but let's keep the adoration and emulation there and avoid punching bathroom walls and/or overdosing. A bit of trivia: Morrison was caught repeatedly in venue and hotel bathrooms destroying décor…in addition, some say that the rocker died of a mysterious illness, while others allege it was a heroin overdose—either way, it was, indeed, in a bathroom.

2944 SE Powell Blvd.

Hopworks Urban Brewery

HOPWORKS URBAN BREWERY (HUB) WAS PORTLAND'S first Eco-Brewpub. It was joined a few years later by its sprightly little brother, Hopworks BikeBar (see p. 124). Owner and brewmaster Christian Ettinger, takes great pride in and receives many accolades for his handcrafted organic beer, made from the freshest local hops and organic barley malt. The brewery itself is sustainably-built and operated: the original building—which, incidentally, used to be a tractor showroom—was professionally deconstructed and all usable materials were recovered, sorted and reused to create the sleek, modern structure that stands now.

A third of the framing material was reused in the reconstruction and all of the finish trim was constructed from recovered trimwork. The booths were crafted entirely from old ceiling joints, and the bar's foot rail is made from old boiler pipes.

The grounds host a rain barrel that captures water to irrigate their exclusively native landscaping. Even their delivery trucks use biodiesel fuel. The menu overflows with organic greens, dressing made from scratch (to cut down on packaging), organic Roma tomato sauce and, grass-fed organic beef. Hopworks is 100% renewably powered and "cradle to gate" carbon neutral. The 20-barrel brewery produces 11,500 barrels of brew a year, with ten different HUB organic beers on tap and two cask ales, 365 days a year.

So, grab a seat in a repurposed booth or prop your feet up on a boiler pipe, order a pint, devour a pizza, and don't leave without tasting a pretzel. In other words: do whatever needs to be done to merit a trip to these wonderfully whimsical washrooms. Ladies, if you don't enter this restroom with a "sunny" disposition, the message on this vibrant yellow wall just might change your frame of mind. The words, "You are beautiful" are gracefully painted backwards on the wall opposite the sinks, reflecting a lovely reminder in the mirror back at us women as we wash our hands.

Gentlemen, you need less reminding and apparently more sleep (or maybe just less beer consumption) because your john is outfitted with banana bike seats mounted above the urinals. Like so many of the other decorative details at HUB, these urinal-aids provide a comfortable, zany, and bike-centric place to relax while you take care of business.

Crush

REMEMBER THE ALLY MCBEAL SHOW? IT INTRODUCED US to digitally-created hallucinogenic dancing babies, the nervous nose whistle, nightly after-work drinks, the occasional sing-alongs with your colleagues, and—most memorably—the unisex bathroom. A late night Ally McBeal rerun, coupled with a limited space to build both a men's and women's handicap-accessible bathroom, helped foster the plan for the shared bathroom at Crush.

This Southeast Portland spot is a casual, hip neighborhood club that has a modern bar area known to serve up some of the tastiest exotic juice margaritas you'll ever encounter. Crush also offers up a plush lounge area, nestled just beyond the bar with gigantic colorful art on the wall, a stage for the occasional burlesque show, and a DJ booth for their almost nightly dance parties. Predominantly a gay bar, Crush is a place that is comfortable, classy, and sassy for people of all orientations.

Whether you're a man, a woman, a man dressed as a woman, or vice versa—it doesn't matter when it comes to the bathroom line at Crush. Three private bathroom stalls share one communal bathroom vanity area. The hallway leading into the bathroom lounge has a mounted chalkboard repurposed from a shuffleboard floor that was torn up during the space's remodel. Draw a doodle or leave a sexy message on the board to entertain future onlookers. The floor plan works brilliantly: dark walls and a vivid blue ceiling are illuminated with an art deco chandelier, while complementary blue tiles dress up the wall behind the sinks. Even on the busiest of nights, the bathroom line moves quickly and the women are not left to wait in a long line or have their girlfriends watch the men's room door while they sneak in for a quick tinkle. Since it is a shared bathroom, those who use it do seem to be neater and more respectful of how they go about doing their business, which is pretty potty perfect if you ask me.

1400 SE Morrison St.

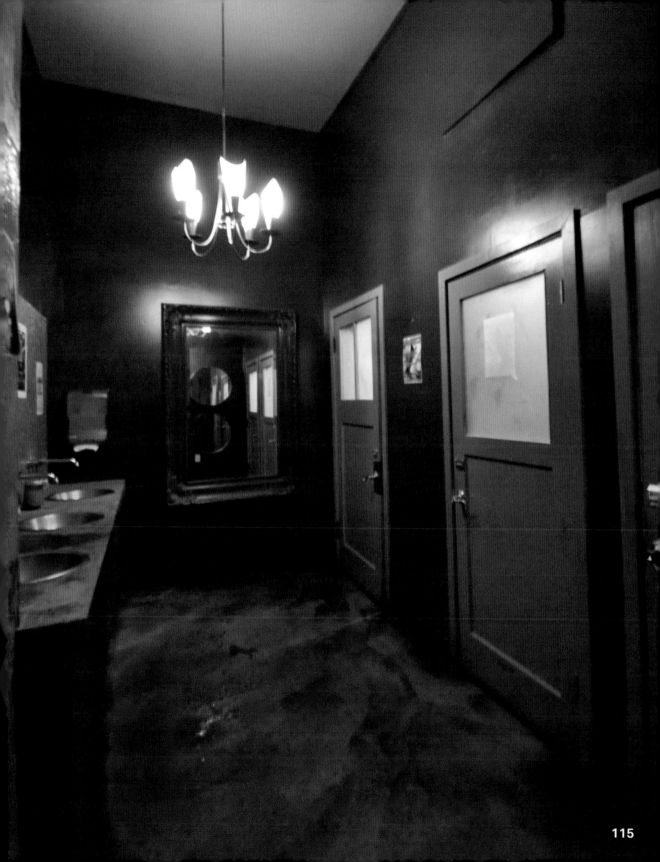

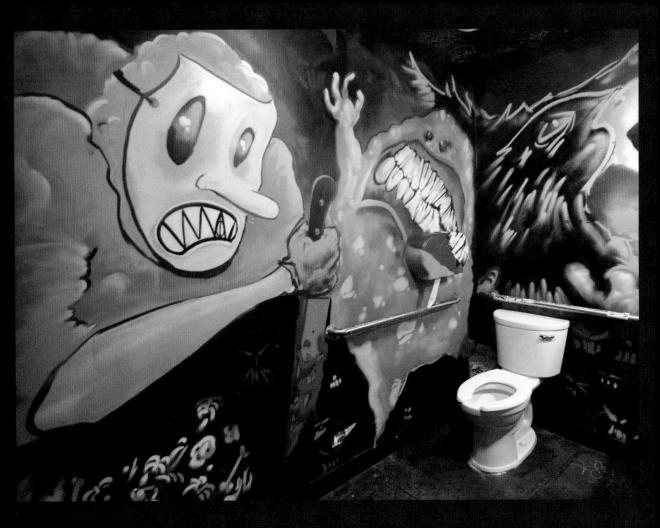

The High Dive

THE POOL'S HIGH DIVE WAS ALWAYS ONE OF THOSE THINGS that I found myself instantly drawn to but infinitely intimidated by. It looked like an adventure begging for a gutsy companion, but once I would climb up the steps, I always found my knees knocking and my heart in my throat. The only thing scarier than actually jumping off the board was the thought of the giant wedgie my bathing suit would inevitably create when I plunged into the deep end of the pool.

The High Dive, located in inner Southeast Portland, *is* an adventure—and I have yet to receive a wedgie from a visit here, so it's way more appealing than an actual high dive. In 2011 Bob Jones and Ryan Pawley gutted what was once an auto mechanic shop and law office building and transformed it into this unique spot.

Jones and Pawley lived and bartended in Portland when the rents were cheap and the drinks even cheaper. With an increased awareness that neighborhood joints were rapidly disappearing and the area was repopulating with expensive craft cocktail bars, these two longtime friends set out to open a small bar that embodied the "neighborhood joint" vibe they so loved.

1406 SE 12th Avenue

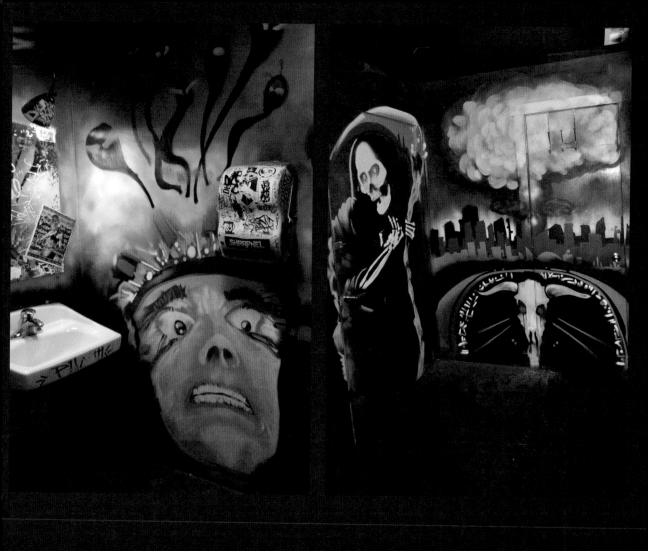

Armed with everything but a bag of cash, Bob and Ryan gratefully relied on the physical help of family and friends and the support of service industry people to create The High Dive. The name is derived from the notion that the establishment is a high-end dive bar.

This unpretentious neighborhood bar emphasizes service, freshly pressed cocktails, a solid selection of booze, rotating local beers, vibrant art and a big, covered, heated patio—perfect for year-round lounging. Plus trivia nights, Taco Tuesdays, and a screening of every Blazers game surrounded by Rip City enthusiasts.

Patrons are encouraged to support the cartopia setup at the corner of the block, grab a bite and bring it back to The High Dive to enjoy with a cocktail or beer.

When nature calls while at The High Dive, be prepared to enter a realm inhabited by Slimer, a knife-wielding murderer, a graveyard full of phantoms, the grim reaper and *A Clockwork Orange*. Jonny Romero is the muralist who unleashed the dark side on the inside of The High Dive bathroom—I'm pretty certain Jonny was master of all the high dives he encountered while growing up.

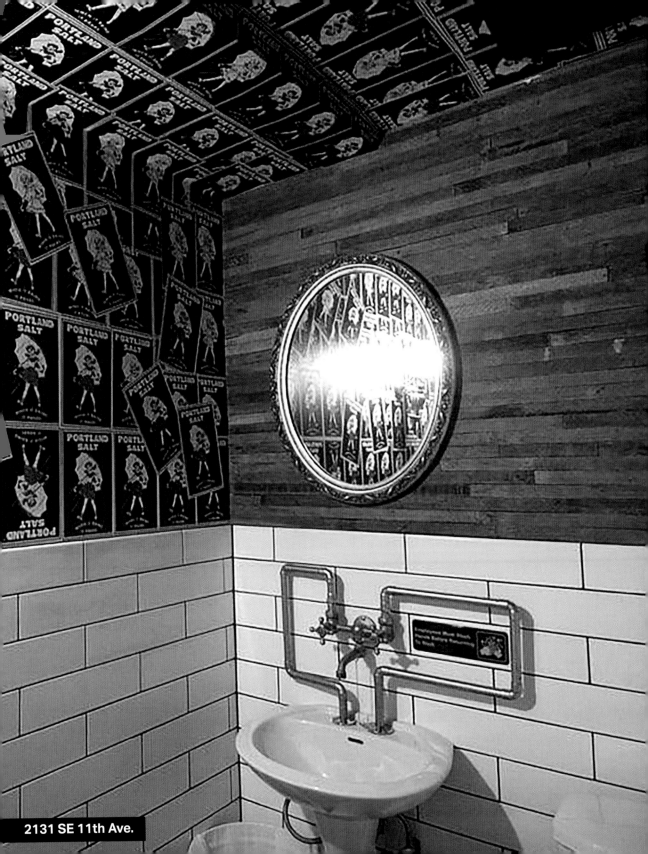

P.R.E.A.M.

IT'S SAFE TO SAY NED LUDD (SEE PG 82) IS KNOWN TO TURN out tasty bites and owner, Jason French, is known for embracing the pulse of Portland's culture of camaraderie.

Two short years ago, the duo of Brandon Gomez and Nick Ford, both new to Portland from New York, found themselves as roommates working under the talented and genuine guidance of Jason French.

Gomez and Ford had a love of hip hop music, a recipe for pizza dough and a desire to dish up their own signature food in an environment reminiscent of their time spent in Brooklyn.

This young duo seized an opportunity that would lead them to serving up wood fired pizza to droves of Portlanders. With permission to utilize Ned Ludd's kitchen and dining room on its dark day, this team started a pop up pizza kitchen called P.R.E.A.M.

P.R.E.A.M. (Pizza Rules Everything Around Me) is a play on the popular WuTang Clan song "C.R.E.A.M." ("Cash Rules Everything Around Me"). The popularity of P.R.E.A.M. was undeniable, and it wasn't long before their Monday night pop up had its eye on Tuesday through Sunday and digs to call their own.

With the help of ChefStable restaurateur Kurt Huffman, Gomez and Ford procured the newly available space of a Southeast neighborhood bar, Tennessee Red's. With that they had all the ingredients needed for their popular pizza pies to rule everything around them.

Gomez gutted and rebuilt, the interior or P.R.E.A.M. from floor to ceiling. Renovations included tearing down walls of Latham (thin wooden strips) and removing all the nails by hand. The Latham strips were repurposed and can be seen behind the bar and on the walls in the restrooms. Recycled gymnasium floors were used to make booths and tabletops.

Aside from the building being a neighborhood fixture, some of the fixtures in the building were made by folks in the neighborhood. Like the wooden front door handle made 20 years ago by Mike, the neighbor who still lives across the street. The needlepoint rap lyrics hung on the wall were also made by a friend and neighbor.

The bathrooms use the reclaimed Latham strips to add texture and history to the space. The salt girl wallpaper was inspired by Ford's memory of working in NYC and frequently having the Morton's Salt container in his hand. One day Ford told Gomez he wanted to get a tattoo of the Morton's Salt girl but give her the face of a misfit. Gomez, being an artist, came back to Ford the next day with a graphic rendition of the salt girl carrying her umbrella, now with a misfit's face. "The Portland Salt Co., When It Rains, It Pours" was a natural tagline.

Bamboo Revolution

BAMBOO REVOLUTION IS AN INNOVATIVE PORTLAND-BASED supplier of bamboo building materials which intends to educate, demonstrate and help others facilitate responsible, sustainable building practices.

Bamboo rapidly regenerates, creating a constant supply of raw material without harm to the ecosystem. The day after cutting the culm, there are up to seven plants in its place, with no need for replanting.

The founders of Bamboo Revolution believe bringing sustainability into our lives is a challenge we must accept as a way of life starting today. Putting this mission statement into practice, in 2009 Bamboo Revolution spearheaded a project to transplant the first live Moso bamboo from Avery Island, Louisiana, to Portland, Oregon. Avery Island is one of the oldest timber bamboo groves in America, first planted in 1910 in cooperation with the USDA. All of the test transplants were 100 percent successful, and as a result the initial phases of cultivating Portland's first bamboo forest has begun.

1300 SE Grand Ave.

Bamboo Revolution shares its beautiful expansive showroom and gorgeous bathroom with Coava Coffee Roasters. Falling in line with the company's desire to inspire and demonstrate the many uses of bamboo, behold behind the large backlit bamboo door, a bamboo bathroom that aims to wow. From floor, to wall, to counter, to ceiling—bamboo is the building material. A beautiful demonstration of the variations bamboo takes, and a fabulous place to pee.

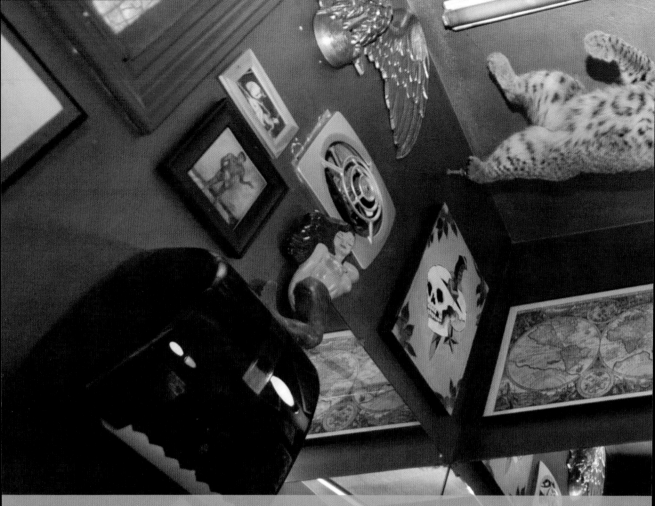

Atlas Tattoo

ATLAS TATTOO RESIDES IN A SEEMINGLY UNASSUMING building in Albina, Oregon—but its legacy is rich and eccentric, with a bathroom that aptly embodies it. The building was once home to the Albina Saloon, an alleged brothel and confirmed gathering place for stevedores, railroad men, and gamblers. It was also home to a shoe repair shop, a hardware store, and the home office for Snipe Hunt, a late '80s/early '90s music magazine. In 2005 the Atlas crew put down their ink guns and picked up their nail guns to renovate the building and make it their new home. The six tattoo artists, Jerry

Ware, Lewis Hess, Cheyenne Sawyer, Jacob Redmond, Corey Crowley, Dan Gilsdorf—as well as the indispensable shop manager, Nic Eldridge—represent over a hundred years of tattooing experience. Together, this group cultivates the perfect blend of traditional tattooing sensibilities with bold, lasting art, creating highly-coveted ink in an atmosphere of raucous banter that ranges from philosophical debates to sudden outbursts of animal noises.

Like the shop itself, its bathroom is an ever-evolving collection of intriguing oddities. A bright red tattooed door invites you in to a menagerie of taxidermy wildlife. A bobcat soars overhead towards an unsuspecting deer, while a black crow looks on from its perch. A mermaid, Jesus, and a samurai also bear witness to this calamity. Many of the items in the loo are gifts from customers and friends of the shop—displayed in a somewhat random and very imaginative narrative. Colorful tattoo art, curious knick-knacks and peculiar pictures line the walls and fill the powder-room peruser with curiosity.

Hopworks BikeBar

PORTLAND IS THE HOME TO OVER 40 BREWERIES — MORE than any other city in the world. Lending itself to nicknames like "Beervana" and "Brewtopia," Portland is also consistently named the number one city in the country for cycling. Put those two attributes together, lease space along the bike commuter route in an eco-friendly building in North Portland, and you have an environmentally conscious, family-friendly, ingenious concept for a bar. BikeBar is the outpost of the well-known, much loved Hopworks Urban Brewery on Southeast Powell Boulevard (see p. 112).

Hopworks BikeBar sits along the main bike commuter route on North Williams Avenue—known to cyclists as "the bike highway." A staggering 3,000 bike commuters utilize this route on a daily basis. Paying homage to these cyclists and adhering to the eco-consciousness of today's lifestyles, BikeBar was created to exemplify both. The bar within the bar is accessorized by a canopy of 40 bike frames crafted by local custom frame builders. The frames add to the aesthetics of the bar's theme, but also serve, for many, as the only venue to showcase their innovative work. Light fixtures made from growlers, and constructed by students from the Pacific Northwest College of Art, hang down from even more bike frames attached to the ceiling. Two Plug-Out stationary bicycles sit at the front of the bar and actually generate electricity back into the building's grid when pedaled. Ninety-nine bottles of beer are featured on the wall—appropriately nestled in bike cages (how clever is that?). Aside from the crafty adornments that dress the space, much of the interior is sustainable and reclaimed. The table tops, bar tops, and wood paneling are all made from reclaimed materials, including the brick wall in the dining room.

Hopworks Urban Brewery installed low-flow toilets in their first location with an eye on the environment, and they stepped up their flush-savvy game with BikeBar's water closet. Stepping foot into this water closet is like entering a rainforest, sans the tropical birds, snakes and humidity. This bathroom boldly imparts the illusion of a rainforest with wallpapered walls of lush, green trees, allowing you to pee in a sleek, modern, and, most importantly, water-saving commode. The hand-washing basin is attached to the top of the toilet tank, which allows the water used to wash your hands to be smartly recycled into the tank for an eco-friendly flush. Now, while you may not hear any lulling waterfalls or rhythmic animal sounds, the peace and quiet of this eco-friendly water closet is priceless, especially if you are dining with or around small children.

3947 N Williams Ave.

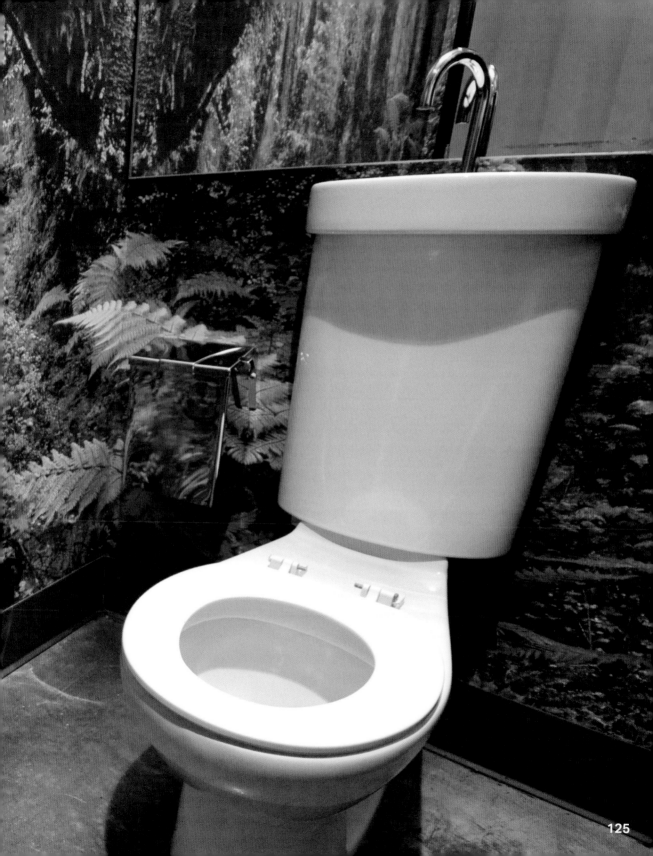

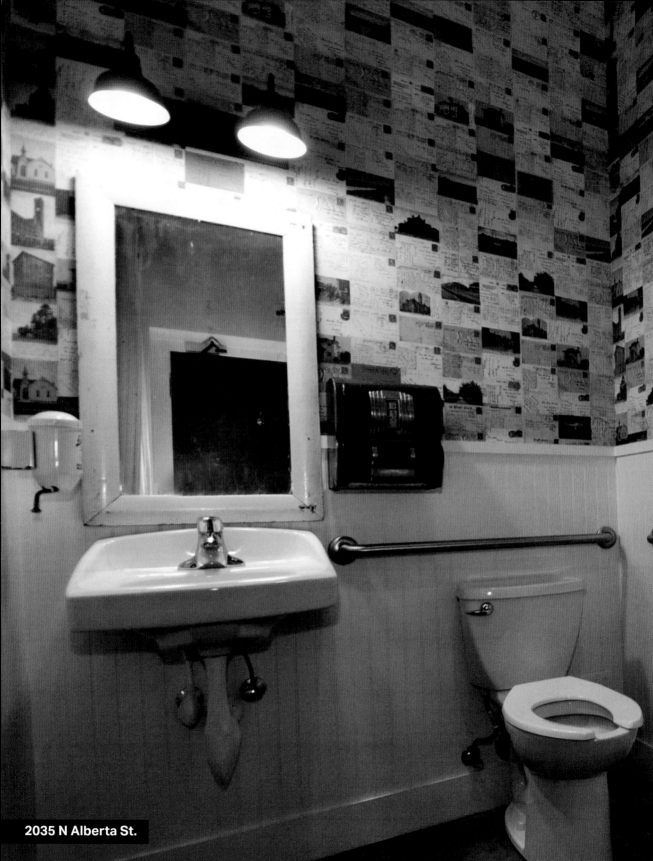

2035 N Alberta St.

Salt & Straw

SALT & STRAW EMPLOYS TWO KEY ELEMENTS WHEN IT comes to making traditional handmade ice cream: rock salt and straw. Rock salt is used to freeze the ice cream and straw is used to keep the ice cream cold.

This "farm-to-cone" ice cream parlor mixes tradition with ingenuity. With flavors such as brown ale and bacon, pear and blue cheese, and foraged dandelion sorbet, "traditional" might not be the first word that comes to mind, but couple local ingredients in unexpected pairings with traditional techniques and you get one hell of a tasty concoction.

What started as a lemon sorbet cart morphed into three jam-packed ice cream parlors in Portland and one in Los Angeles. Their ice cream is handmade in small batches, using the best local, organic and sustainable ingredients Oregon has to offer. Salt & Straw has indeed done for ice cream what microbreweries have done for beer.

Tradition, history, and artistry continue to mingle on the walls of the bathroom in this darling ice cream parlor. Owner Kim Malek unearthed a collection of postcards from a local resident, Miss Ada, dating back to the early 1900s. Miss Ada faithfully kept in touch with her friends both near and far via postcards that capture the time-honored tradition of written correspondence. The story that unfolds on the backs of these vintage cards captivated Kim and her crew. They loved Miss Ada's adventures so much that they turned the collection into wallpaper—now anyone who visits the loo at their Alberta Street location can share a few private moments getting to know Miss Ada, too.

23226 N Flint Ave.

Ex Novo

PORTLAND IS NATIONALLY RECOGNIZED AS A HUB OF IN-
novative people—people who also happen to love
their craft beer. Many Portlanders have even figured
out how to get a kegerator approved for their office
break room! But did you also know Portland has
more nonprofit organizations per capita than any
other city in America? It's no surprise then that the
first nonprofit brewery in the country—Ex Novo
Brewing Co.—was opened here in Portland last
year. Husband and wife Joel and Sarah Gregory
opened Ex Novo Brewing Co. in North Portland on
July 11, 2014.

Joel and Sarah envisioned an inviting, casual, fam-
ily friendly brewery that would offer something more
than great beers and a great space—it would also offer
the opportunity to help others.

"We are passionate about social justice and
helping others, both locally and globally. We seek
to partner with organizations doing good work
and doing it well," the couple says. After covering
costs and building a small reserve fund, all of Ex
Novo's net profits are evenly distributed among
four partner organizations: Friends of the Children,
International Justice Mission, Impact NW and
Mercy Corps.

The name Ex Novo comes from Latin, meaning:
from the beginning, or from scratch. It's the perfect
name for this brewery. Everything about this proj-
ect—from the concept, to the brewing, to the business
model—was created from scratch.

Taking over an industrial building that was once
home to Eleek, a lighting and fixture design company,
Ex Novo has succeeded in creating a space that is casu-
ally chic and very inviting. Huge garage doors open up
the space to fresh air and grassy views of the park across
the street. The bar top is made from Doug fir wood. The
walls are lined with reclaimed redwood from Portland
fences, and an upstairs seating balcony overlooks the
brewery below. Jonathan Case is the local artist who cre-
ated the retro inspired art piece that used both the "from
scratch" theme and "brewing elements"—seen center
stage on the wall leading to the upstairs dining area.

Sarah and Joel believe parents deserve a night out
to enjoy a craft beer, some tasty food and a kid/parent
friendly bathroom! The bathrooms at Ex Novo are
lined with the same reclaimed redwood from Portland
fences, cut at 55 and 35 degree angles to create a her-
ringbone effect. The light fixtures are remnants from
Eleek, the previous tenants. You'll also find antique
tables, repurposed into changing stations well stocked
with diapers and wipes. Cheers to all the well deserv-
ing moms and dads out reconnecting with friends and
enjoying a meal with family while sipping on great
beers, like Ex Novo's How the Helles Are Ya?, a full-
bodied pale lager, or Damon Stoutamire, a medium-
bodied Portland stout.

The Box Social

A BAR BY ANY OTHER NAME IS...A DRINKING PARLOUR!

What exactly is a drinking parlour? Envision an intimate, boxy little babe of a place with long, plush drapes dressing the windows, an impressive wall mural of the Portland night skyline and votive candles creating ambient lighting. The beautiful wood bar complements the magnificent cocktails that are crafted behind its solid foundation. Welcome to Eric and Shannon McQuilkin's North Portland drinking parlour, The Box Social.

The McQuilkins are longtime residents of the Williams Neighborhood in North Portland. Having worked many years in the restaurant industry, Shannon noticed there was a serious lack of neighborhood bars open late where one could get a well-made cocktail. And it's said by those who know Eric and Shannon well, they do love a good cocktail. Armed with a desire to tackle a new project—coupled with a real neighborhood need and their unrelenting love of a good Old Fashioned—they created The Box Social.

The McQuilkins' design concept included cozy inviting and quirky elements. They wanted a dimly lit space—"not everything needs to be seen or heard," says former attorney Eric.* The Box Social is exactly what they envisioned: a neighborhood bar with artisanal cocktails, beer, wine and tasty small bites—plus it's open late every night of the week.

Eric and Shannon say their philosophy behind the tagline "a drinking parlor" is their desire to keep their guests feeling comfortable and at home. At the same time, they strive to always take the making of drinks seriously, but never themselves. Shannon says the bathrooms were far from the last detail they visualized. They were purposely designed as unisex and different. One bathroom represents the sophisticated, sexy side of The Box Social, while the other embodies the nonsense of it all. This room will likely evoke a giggle which perfectly complements Eric and Shannon's motto to never take themselves too seriously. These bathrooms are funky and fan-CAT-stic.

*That's irony I didn't even need to embellish

3971 N Williams Ave.

THE FUNKY

AND FABULOUS

FACTS

ABOUT

PORTLAND

The Funky and Fabulous Facts About Portland

The fact that Portland has a book highlighting its funky and fabulous bathrooms (and it's actually being bought by people other than my mother) is just one of the many uniquely endearing and mildly weird aspects of this city. "Keep Portland Weird" is the unofficial city motto said lovingly by locals and hashtagged frequently by visitors. Here are a few quirky, fun, mildly weird facts that have made Portland's motto so treasured.

Population
2 million in the Portland metropolitan area

Area
135 square miles

Elevation
Average of 173 feet above sea level

Official Bird
Blue heron. In 1986 Mayor Bud Clark proclaimed the big, gangly birds to be Portland's official city bird. These are a sensitive species and will abandon areas that become too disturbed.

City Flower
Roses

Miles to the Pacific Ocean
78

Miles to a Glacier
65 miles to Palmer Glacier on top of Mount Hood. At 11,239 feet Mount Hood is the tallest peak in Oregon and is a dormant volcano.

City Motto
"The City that Works," adopted in 1995. The motto can be seen on all city work vehicles.

PORTLAND NICKNAMES

Little Beirut
A nickname given by George Bush and his staff. Every time Bush would visit, there would be such protests and demonstrations that he did not return to Portland when seeking reelection in 2004, but he did send other staff members to try to gain support.

Puddletown
Pretty obvious. More than 36 inches of rain a year makes a whole lot o' puddles. This makes it the perfect city to wear those fashionable rubber boots with warm knee-high socks!

Stumptown
Coined during a period of phenomenal growth in Portland after 1847. The rapid development of the city called for trees to be cut down, making room for roads. The stumps were left behind until manpower could be spared to remove them. These stumps also became useful as stepping stones to cross the street without sinking into the mud.

PDX
The International Air Transport Association airport code for Portland International Airport, which is within the city limits. The code refers to the city as often as it does to the airport.

City of Roses
A popular nickname after the 1905 Lewis and Clark Centennial Exposition. Mayor Harry Lane suggested that the city should have a festival of roses. Two years later began the tradition of the Portland Rose Festival, which remains the city's major annual festival a century later.

Another founding story goes like this: Leo Samuel, founder of the Oregon Life Insurance Company in 1906 (known today as Standard Insurance Company), grew roses outside his home and placed a pair of shears outside his garden so people could snip a rose to take for themselves. This encouraged other people and businesses to plant roses outside their homes and places of work. Today, roses are still planted outside Standard Insurance Company's home office building in downtown Portland.

Beervana
Portland has more brewpubs per capita than any other city in the United States.

Bridgetown
The Willamette River divides Portland into east and west. The Columbia River, to the north, separates Oregon

from Washington. In total there are eleven bridges throughout the Portland area, including eight in the central area and three over the Columbia.

Rip City
Used in the context of the city's NBA team, the Portland Trail Blazers. The term was coined by Bill Schonely, the team's play-by-play announcer, during a game against the Los Angeles Lakers on February 18, 1971, in the Blazers' first season.

P-Town
An affectionate abbreviation some locals use

PORTLAND PHRASEOLOGY

The mountain is out.
Literally meaning that you can see Mount Hood from the city. The phrase generally implies that it's a nice day out, with nothing in the sky to obscure spectacular views of the mountain.

Brewmoo
Brew/movie, relating to any number of theaters that serve beer. Most notable are the McMenamins theaters throughout the city such as Kennedy School, Bagdad and the Mission Theater. Others are Laurelhurst, Cinema 21 and Living Room Theaters.

The MAX
An acronym for Metro Area Express, the light-rail system that runs throughout Portland and some surrounding suburbs, including the airport

Spendy
The locals' way of saying expensive

Freddie's
One of Oregon's most widely spread retailers, Fred Meyer. It was Oregon's version of Target before we had a Target. The original is on Burnside at 21st.

Pill Hill
The hill that houses teaching hospital OHSU, Doernbecher Children's Hospital and the VA hospital

The Silver Bullet
The aerial tram that carries people in an air-conditioned silver pod from the waterfront parking areas, over I-5, to the top of Pill Hill. Even if you're not visiting someone on the hill, you can still hop on the tram for a ride with spectacular views.

Stumptown
Originally another nickname for Portland, now better known as the local coffee company

Portlandia
A 36-foot-tall statue created by Raymond Kaskey. *Portlandia* is the second-largest hammered copper statue in the United States (only the Statue of Liberty is larger). She's located at the Portland Building in downtown Portland at SW 5th Ave. The statue is a women modeled after the Lady of Commerce depicted on the city seal. She is dressed in classical clothes, holding a trident in her left hand and reaching down with her right hand to greet visitors.

Powell's
Referring to Powell's City of Books, the largest new and used independently owned bookstore in the world. Located downtown off East Burnside, Powell's occupies an entire city block. The bookstore is so large, the information desk offers maps of the bookstore for your wandering pleasure. Smaller versions of Powell's can also be found on the east side, at the airport and in the suburb of Beaverton.

Zoobomb
An event that has been going on for more than a decade. Every Sunday evening enthusiastic people meet at the corner of SW Stark and East Burnside, where a city-commissioned statue holds a collection of bikes stacked high on a curving post. The bikes are unlocked from the statue and divvied up. Everyone rides the MAX up to the zoo. Bikers then "bomb" down the hill on Burnside on these bikes.

Big Pink
Nickname for Portland's 546-foot-tall US Bancorp Tower. The nickname is derived from the building's exterior color. At sunset Big Pink really shines to the heavens. On the very top of the Bank Corp building is Portland City Grill, whose amazing views make it one of Portland's most popular places for happy hour.

Bioswales
Curb plantings used as natural filters to keep the Willamette River and other waterways clean during large rainstorms. Portland has installed over 1,350 bioswales.

Pod
A group of food carts. Portland has over 700 food carts, and most of them are clustered into pods.

Bubblers
The bronze four-bowl drinking fountains seen throughout downtown. In 1912 the Benson Bubblers were a gift to Portland from businessman Simon Benson. 52 true Benson Bubblers can be found throughout downtown. 74 single-bowl variations are also scattered throughout the city.

Portland's Living Room
Pioneer Courthouse Square. People consider this courtyard to be Portland's living room, and it's home to year-round festivals, events, lunch breaks, KGW News and the huge holiday tree.

The Schnitz
Refers to the historic Paramount Theatre, now known as the Arlene Schnitzer Concert Hall, a beautiful theater downtown that hosts concerts, conventions and the ballet.

PORTLAND WEIRD AND WONDERFUL. DID YOU KNOW...

It's against the law to pump your own gas. In Oregon, it's a state law that only the station's attendant may legally operate the pump. Do it yourself and you'll get slapped with a $500 fine. New Jersey is the only other state that has this law.

Portland is settled around an extinct volcano, Mount Tabor, and within 70 miles of two dormant volcanoes, Mount Hood (in Oregon) and Mount Saint Helens (in Washington).

Every summer for close to a decade, Portland hosts the annual World Naked Bike Ride. The aim of this bike ride is to bring awareness to cycling safety and pollution reduction. Attendance in 2015 was over 10,000 people of various shapes and sizes.

The famous White Stag sign, also known as the Made in Oregon sign, located in downtown at 70 NW Couch Street, welcomes westbound traffic as it enters downtown. The day after Thanksgiving through the holiday season, a red bulb is lit on the stag's nose for holiday cheer.

Over 100 years ago, drinking in Portland was a dangerous gamble. It wasn't traditional crime that people were fearful of—there was serious risk of being shanghaied on a boat to another country. Portland's Shanghai Tunnels connected the basements of many downtown hotels and pubs to the Willamette River's waterfront. Originally built to move goods from docked ships, these tunnels created a network of passages that were used by unscrupulous individuals called "shanghaiers" to move drugged and kidnapped individuals onto ships and into slavery and prostitution. Today walking tours are led through parts of these tunnels.

Oregon has no sales tax. The price is exactly what the tag indicates, so go ahead and splurge a little while you're here!

Portland routinely pops up on lists of the top cities for mass transit in the country. Our comprehensive transportation system includes commuter rail and buses, light-rail and streetcar lines, and a plethora of bike and pedestrian paths. Portland was one of the first American cities to reintroduce modern streetcars in 2001.

Portland is ahead of the curve when it comes to sustainable urban planning and is always winning various awards for its environmental awesomeness. It's common for locals to be raising chickens, goats and rabbits as well as growing plentiful vegetable gardens in their backyards. Locally sourced everything is common ritual at just about every restaurant in the city.

Car horns are rarely used.

Portlanders are polite, law-abiding people, with a tendency to wait it out at a stop sign because everyone is waving everyone else on, yet no one is going.

Throughout the city, Portland's fountains are chlorinated and often used as a cool place to frolic when the temperatures soar.

Unlike practically every other city in America, Portland does not fluoridate its drinking water. So tell your children to become dentists and move to Portland—they'll always have clients and enough money to care for you in your twilight years!

If you live here, you'll have to buy a bicycle. *Bicycling* magazine rated Portland the #1 Bike-Friendly City in America in 2012. Twelve times more commuters travel by bike in Portland than the national average, and there are 319 miles of bikeways. Bike riding doesn't make us weird, but the sheer amount of unicyclists kinda does. The most beloved of them is the Unipiper, a unicycling Darth Vader who plays flaming bagpipes!

After you buy a bike, you'll next need a dog. With 33 dog parks, plenty of dog-friendly restaurants and hotels, it's no wonder Portland was named the #1 US City for Dogs by *Estately*.

Aside from happy hour, breakfast is the most important meal of the day in Portland, which is why people will wait hours in line for it. However, the city is home to an incredible number of delicious breakfast spots. Be sure to get the book *Breakfast in Bridgetown* by Paul Gerald for an extensive breakfast list accompanied by reviews that are down to earth and not snobbish.

Shortly after the breakfast hours, it's happy hour time in Portland. Some happy hours start as early as 2 p.m. in the city. It's easy to be well fed and slightly tipsy for under $20! Be sure to pick up the *Happy Hour Guidebook* by Cindy Anderson for descriptions of over 600 happy hours throughout the city!

Portland is the fifth most tattooed city in America (Miami is #1).

Portland is home to Mill Ends Park, the smallest park in the world. Only two feet across, it's located downtown in the middle of a crosswalk on SW Natio Parkway at Taylor Street.

On the flipside, Forest Park is nearly 5,000 acres and is the largest urban park in the United States.

Strip clubs! Portland has more strip clubs per capita than both Las Vegas and San Francisco. We even have a vegan-friendly strip club! No leather is worn—but then again not a lot of anything is worn inside that sort of establishment, so is this really that special?

Reusable bags are a must-have. As one of the greenest cities around, Portland passed a law against plastic bags within city limits. All stores now use paper, but many Portlanders bring their own reusable bags.

Ah, the free pile. Portlanders love to reduce, reuse and recycle. One way they do this is by leaving random usable and not-so-usable goods out in front of their home, free for anyone to take.

Poetry post, poetry pole or poetry box—you say tomato, I say tomato! The gist of this yard decor can simply be described as a wooden box (similar to a shadow box) affixed to the top of a wooden post. Inside the box is a poem—or prose or lyrics. In Portland we have a comprehensive online map pinpointing poetry posts through the city: http://poetrybox.info.

All throughout the city, you can find miniature toy horses tied up on hitching rings. The rings were remnants of a bygone era. They were removed from the curbs and sidewalks for safety reasons until 1970, when a resident complained about the rings' disappearance. Today the city preserves the rings by requiring them to be replaced following sidewalk construction. 2015 marks the 10-year anniversary of the Portland Horse Project. The project is a citywide art movement that encourages citizens to use the iconic rings to tether up miniature toy horses. See how many you can find on your exploration of Portland!

About The Author

As the girl who authored the book everyone else claims they *could have* and *should have* written—Kelly Melillo has always been intrigued by nuggets of quirky trivia.

With a Bachelor of Arts in Criminal Justice from Kent State University and various jobs such as waitress, parole officer, paralegal, blogger, citysearch scout, airbnb host, author, traveler, volunteer, networker, skincare consultant, hilarious friend, pretty good wife turned most intriguing girl to date on Tinder—and awesome mother—anyone can clearly see the professional progression that lead her to write this book.

As an avid connector of people, stories and possibilities, Kelly says researching and writing this book not only made her happy, it created a rich and colorful connection to the city she lives in and loves—Portland,Oregon.

Remembered for many odd reasons, Kelly says one of her favorites is receiving texts or tags that announce: "I was just in this weird bathroom and immediately thought of you!"

Kelly currently resides in Portland, Oregon, with her three sons. When she's not busy making lunches (with love), attending sporting events (wearing rain boots), or being schooled in how to play various Wii games (unsuccessfully), she fancies herself an urban archaeologist uncovering the next neighborhood treasure trove of stories and fun times. And on occasion, she's been spotted dancing on tables and fleeing from zombies.

WHERE

SHOULD

I GO NEXT?

The Best Places To Pee has been a fun and creative way to learn about the city of Portland, Oregon, and I believe it would be just as entertaining and successful in your city!

Join me, as a member of The Loo Crew, and post pictures on social media of the funky and fabulous bathrooms you encounter.

Don't forget to use the hashtag #BP2P (Best Places 2 Pee) and hashtag the bathroom location and city!

Facebook
Portland's Funky & Fabulous Bathrooms: The Best Places To Pee

Instagram
keek22

Twitter
PdxGoGirl

Website
www.TheBestPlacesToPee.com